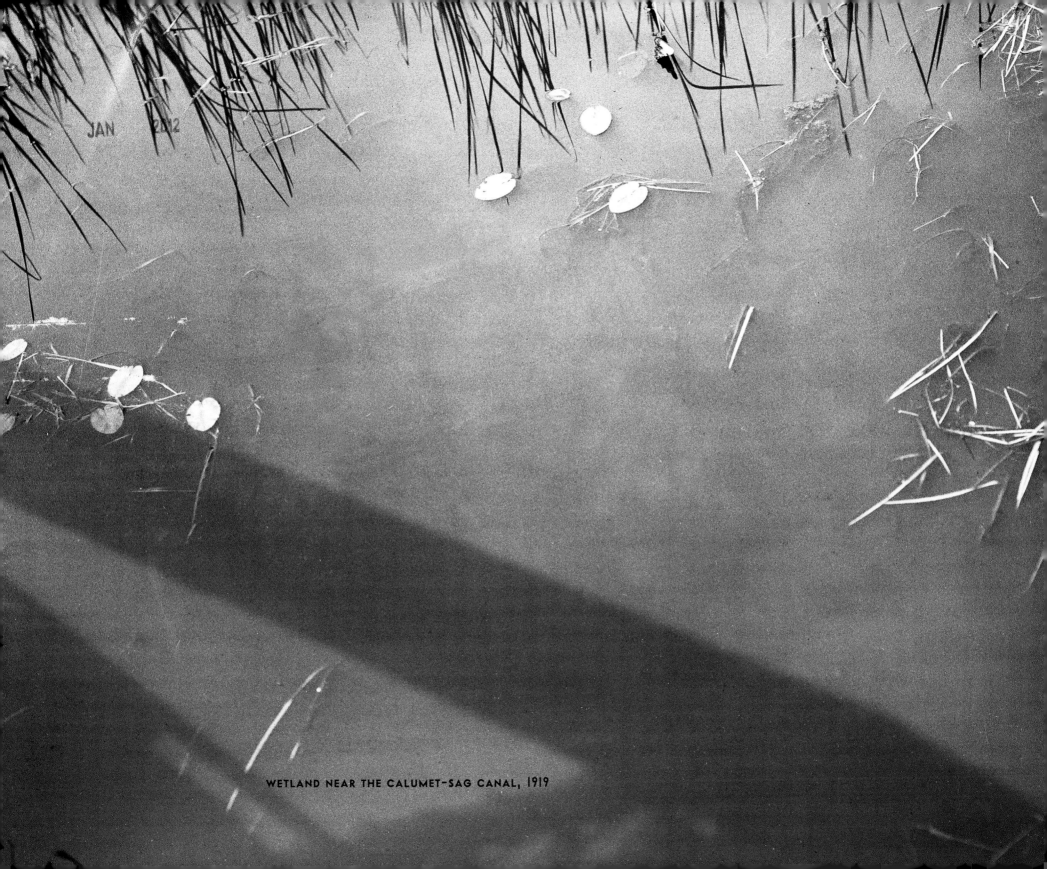

JAN 2012

WETLAND NEAR THE CALUMET-SAG CANAL, 1919

THE LOST PANORAMAS

WHEN CHICAGO CHANGED ITS RIVER
~ AND THE LAND BEYOND ~

RICHARD CAHAN & MICHAEL WILLIAMS

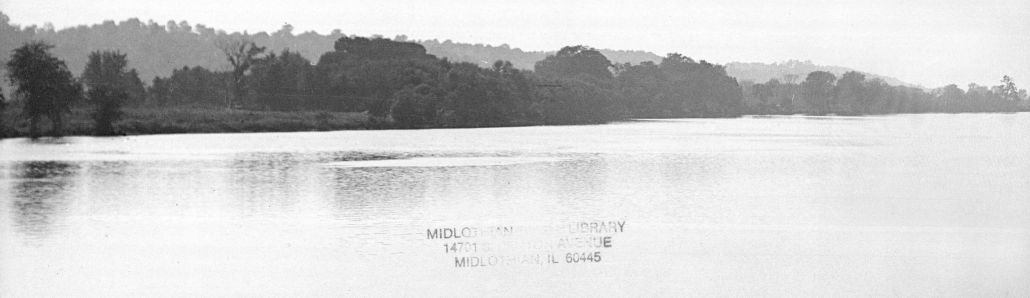

A CITYFILES PRESS BOOK

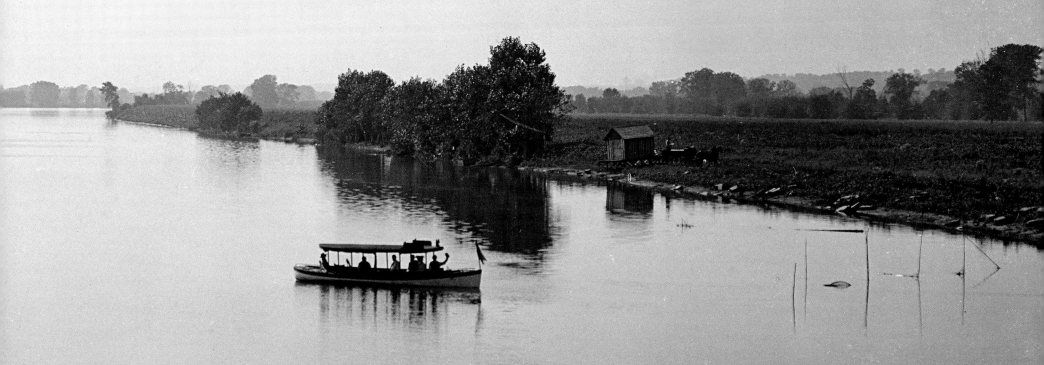

ILLINOIS RIVER AT SPRING VALLEY, 1905

Published by CityFiles Press, Chicago, Illinois

Produced and designed by Michael Williams

ISBN 978-0-9785450-0-0

First Edition

Printed in China

SOUTH BRANCH OF THE CHICAGO RIVER, 1905

CONTENTS

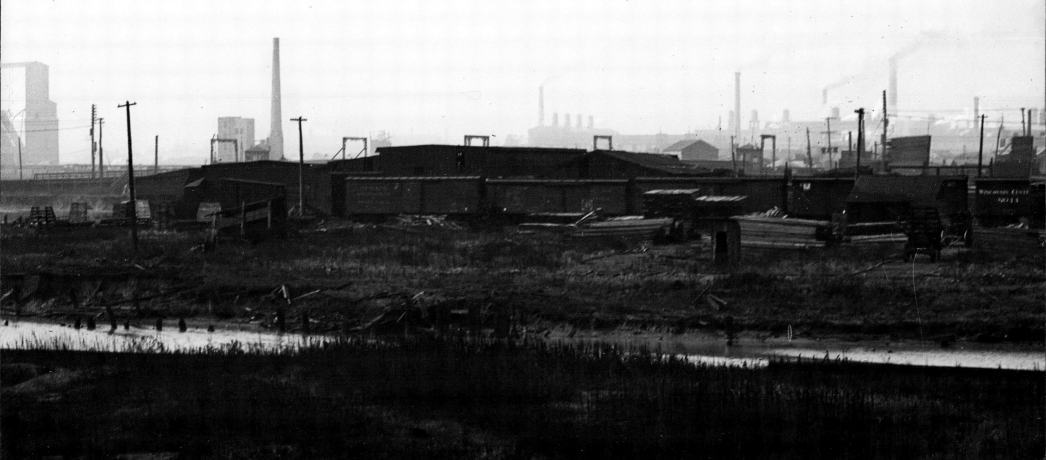

THIS BOOK HAS BEEN GENEROUSLY
SUPPORTED BY THE FOLLOWING:

Lead Sponsor
Greeley and Hansen

Sponsors
Chicago Academy of Sciences and its
 Peggy Notebaert Nature Museum

Christopher B. Burke Engineering, Ltd.

Donors
The Illinois Section of the American Society of Civil Engineers
Richard Lanyon and Marsha Richman
Judith M. Anderson
AECOM
CDM
Randy R. Rogers
Ronald French
James and Karen Urek
Gerald W. Adelmann

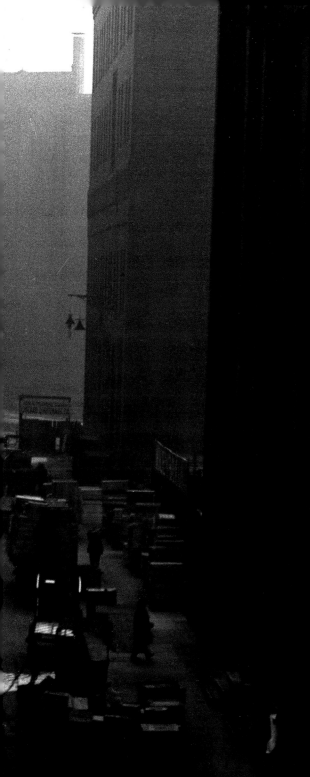

ACKNOWLEDGMENTS

The authors would like to thank Richard Lanyon, former executive director of the Metropolitan Water Reclamation District of Greater Chicago, who contributed and helped us raise money to produce this book after his retirement, and provided essential information throughout the entire project.

Gerald Austiff, the district's information resource supervisor, provided us with everything we needed, from thumbnail scans and field books to encouragement. Jerry grew up near Meredosia on the Illinois River, so this subject is close to his heart.

Deborah Lahey, president and CEO of the Peggy Notebaert Nature Museum, and Marc Miller, vice president external affairs, provided insight, trust and support. Alvaro Ramos, vice president of exhibitions, and his staff helped us create an exhibit that proved how important it was to produce this book.

David Joens, director of the Illinois State Archives, and Dan Smith, of the records center, made us feel at home on our trips to Springfield.

Research help came from Mary Goljenboom, of (aptly named) Ferret Research, who tracked down vital information about the *Lost Panoramas* photographers, and Aaron Cahan, who helped scan negatives. Dennis McClendon provided the map on Page 154; Amy Schroeder provided invaluable copy editing, and ace proofreader Caleb Burroughs caught our mistakes.

Gerald Adelmann got this project off the ground; James Zabel explained the district's lawsuits; Doug Blodgett, of the Emiquon National Wildlife Refuge, taught us biology; Sunny Fischer set high standards; Joel Greenberg inspired us, and Claire Cahan saved the day. Thanks also Patricia Young, Bob Horn, Richard Babcock and his class of journalism students.

Most important are our wives, Cate Cahan and Karen Burke, who are the major supporters of CityFiles Press, and our children and grandchildren—Elie, Claire, Aaron, Glenn, Madeline and Caeden—who are the future.

MARKET AND VAN BUREN STREETS, 1908

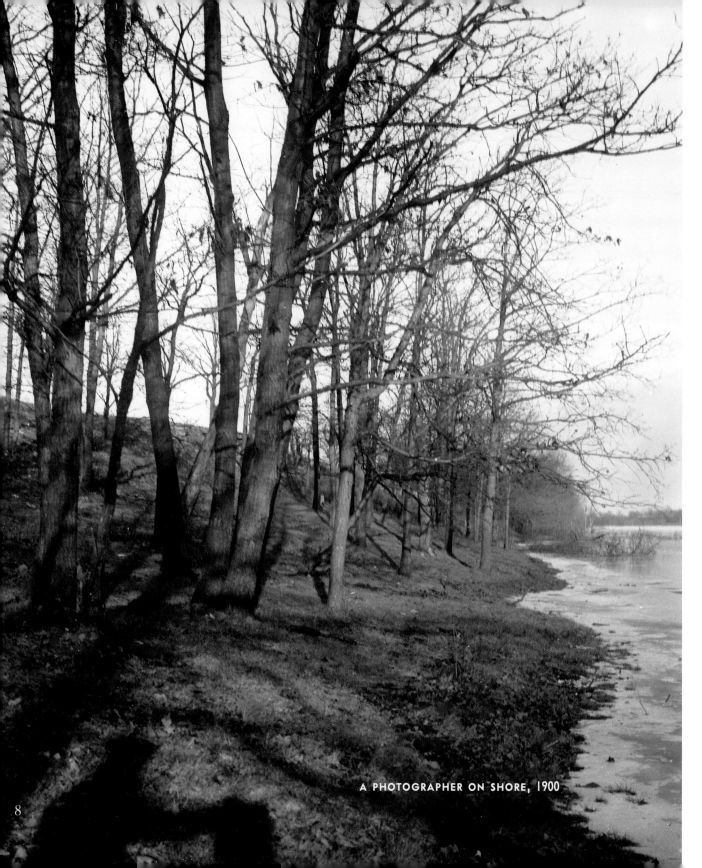

A PHOTOGRAPHER ON SHORE, 1900

8

MOST OF THE PHOTOGRAPHS in this book have never been seen before. Few were ever printed. Taken for the Sanitary District of Chicago between 1894 and 1928 to document the reversal of the Chicago River and its effect on the region, the glass-plate negatives were packed in custom-made slotted wooden boxes and stored so well that they were nearly forgotten. They were hauled around every decade or so, from the district's main offices to storage rooms in buildings all across the metropolitan area.

The 21,834 photographs show what Chicago and the Illinois Valley looked like a century ago. Nearly every photo is panoramic in nature—wide-angle, unobstructed views of a world that no longer exists. Several hundred are actual panoramas, sets of two, three, or four or more plates that show the complete landscapes of downstate farms along the Illinois River. For decades, these multiplate panoramas held a secret. Filed upright, frame by frame, they never hinted that their horizon lines matched and that they were meant to be viewed as a whole. Just recently did we discover that they fit together—like a jigsaw puzzle.

We were originally attracted to the photos by their quiet beauty. Their simplicity and lack of artifice allow them to transport us back in time. The urban images reveal a new side of Chicago, a view from its river during the years not long after the fire of 1871. The rural images, with the earthy aura of Monet's haystacks, remind us that nature, too, has a history. All of these photos are imbued with the

same adventurous spirit of the geographical and geological surveys made of the United States in the late nineteenth century. They lead us to places seldom seen before by cameras. They tell a story of land and river, city and countryside. And like all evocative photographs, they serve as metaphors for larger issues—in this case, nature, progress, and culture.

THE NEGATIVES WERE DISCOVERED by accident not long ago in the basement of the James C. Kirie Water Reclamation Plant in the Chicago suburb of Des Plaines. Administrators from the Metropolitan Water Reclamation District of Greater Chicago (formerly the Sanitary District of Chicago) were called to the plant by workers who complained about the acrid smell emanating from deteriorating film negatives in storage. The negatives, made by photographers hired by the Sanitary District in the 1930s and 1940s, were not salvageable, so the workers were told they could be thrown out. As the administrators were leaving, the plant services manager, Michael Shukin, asked, almost as an afterthought, "What do we want to do with these?" There, on steel shelves—alongside time sheets, purchase orders, contracts, and operations records—sat 130 heavy boxes, stenciled by year, of glass-plate negatives. Over the next three years, the negatives were inventoried and scanned. They were placed in cardboard bankers boxes and transferred to the Illinois State Archives in Springfield, where they remain today.

What makes the photos historically valuable is that they come with detailed descriptions. Each photograph has a date and a negative number, which refers to a set of leather-bound field books that meticulously pinpoint where every photo was taken. Most, but not all, of the field books have survived. About twenty thousand of the nearly twenty-two thousand negatives are tied to an exact location. The field books, written by hand, usually in pencil, also give insight into the photographers' lives and their work, since they doubled as expense accounts. Here you will find what kinds of cigars they smoked, the price of gas, the names of small-town hotels.

WHAT SURPRISED US MOST during our work on this book is that these lost panoramas—the ones in real life—still exist, at least as remnants southwest of Chicago. Many of the backwater lakes and bottomlands were long ago drained and leveed, and the floodplain forests have eroded and disappeared. But as we traveled the Illinois River route that the Sanitary District photographers documented so well, we were startled to see just how much is still there.

As quiet as they are, these photographs possess a unique power. They serve as evidence of a land we thought we knew. They connect us to a world gone by and help us better understand today's world and our place in it. They record Chicago's rise as a midwestern metropolis, the Gem of the Prairie, and remind us of the beauty of Illinois—and how haunting it is that we lost so much of it.

This is the story of how a big city alienated its neighbors and sacrificed the natural world in order to grow and prosper. Chicago never looked back. Until now.

PART I

THE 8ᵀᴴ WONDER *of the* WORLD

CHICAGO'S AUDACIOUS SCHEME TO REVERSE THE COURSE OF ONE OF AMERICA'S CRUCIAL WATERWAYS

PREFACE

THE STORM DOUSED CHICAGO with relentless rain—six inches came down on August 2, 1885, the second-worst drenching in the young city's history. Sewers backed up. Basements flooded. Rainwater soaked the sheet music at Lyon & Healy's downtown store and washed away the gravel on Lake Shore Drive. A persistent stream poured into the Palmer House, knocking out the hotel's boilers. The Des Plaines River overflowed its banks and sent water toward Chicago, where it filled pedestrian tunnels beneath the Chicago River. Even Alderman Edward F. Cullerton, known as Foxy Ed, couldn't outwit this storm. The basement of his two-story South Side home, near Paulina and Twentieth Streets, was deep in muck.

But the storm was seen as something of a blessing in certain circles. Grimy Chicago had been given a shower. Rainstorms in those days were called freshets because they washed down the dusty streets and the slimy sewers and catch basins. The *Chicago Daily News* reported that the city on August 3 was likely the cleanest on the continent.

Chicago's water source to the east was a different story. If you looked closely at Lake Michigan, you would see a dark mass of oil, dirt, and sewage on the move. The sludge seeped from the Chicago River toward a water crib two miles offshore. That crib was positioned to suck fifty million gallons of drinking water a day from the lake down a pipe that sent it back through a tunnel to the city's new waterworks. The crib was to be the answer to Chicago's growing need for clean water, but now it was surrounded by filth.

Within a day of the storm, an influential civic group called the Citizens' Association started to investigate. Members understood that Chicago had long been poisoning its water source. For years, booming factories and jammed stockyards had dumped refuse into the Chicago River. On stormy days, when the wind blew just right, waste flowed into the lake. Something had to be done if the city was to survive.

The group—mostly business leaders and builders—wanted to see for themselves and set out to visit the crib on August 5. They made it only as far as the dock at LaSalle Street; city officials told them that northwest winds prevented such a trip. Although the crib keeper declared that the water was clear and good— the best in the world, in fact—the engineers in the Citizens' Association knew better. The group soon showed chemical proof that the lake water at the crib was indeed contaminated, and suggested that residents were in dire peril of contracting cholera. "This is what the majority of people of Chicago will have to drink for days to come," reported the *Chicago Daily News*.

To combat the threat of disease, the group submitted a plan whose solution was the brainchild of Ossian W. Guthrie, a master mechanic, practicing engineer, and amateur geologist with a serious and thoughtful demeanor. Considered something of a genius— and a crank—Guthrie was a know-it-all who for decades kept detailed daily records of Lake Michigan water levels and was always announcing his "discoveries" in newspapers and professional journals. He had twice been rather soundly defeated for public office, but he kept coming back.

Guthrie suggested that the city build a grand canal to carry water from the dirty Chicago River west to the Des Plaines and Illinois Rivers instead of letting it flow east into Lake Michigan. To demonstrate how such a canal could use simple gravity to redirect and reverse the Chicago River, he took reporters on carriage rides over moraines, to climb slopes of glacial riverbeds southwest of Chicago, and to visit preglacial quarries. Guthrie's idea was to connect the Chicago River to an artifical channel that would run just a few feet lower than Lake Michigan. If built correctly, it would permanently draw the river and even the lake down its path.

In effect, Guthrie and his colleagues proposed busting the divide that separates the Great Lakes basin and the Mississippi River watershed. This would send Chicago's sewage once and for all southward toward St. Louis and the Gulf of Mexico. A century later historian Donald Miller called the idea "heroic chutzpah."

At the time, the audacious plan was called "Mr. Guthrie's Wildly Impractical Ideas." It sought to bend nature in a way that was nearly impossible in most parts of the country. But on America's flat prairies, molding a canal that could draw water to distant coastlines on different ends of the continent just might be feasible. This book details the building of that project, the Chicago Drainage Canal, affectionately known in the 1890s as the Big Ditch and today called the Chicago Sanitary and Ship Canal or Main Channel. It ranks with the first transcontinental railroad, the Eads Bridge over the Mississippi, and the Brooklyn Bridge as one of America's most decisive engineering achievements of its age. But it stands apart because every facet of the canal's construction and the effects of that work can still be seen a century later in a singular set of more than twenty thousand glass-plate negatives.

The trustees of the Sanitary District of Chicago were justly proud of the canal, so they hired photographers to document the creation

of this masterpiece of the Midwest. The photographers gave little thought to the artistic value of their assignment, but they could not help but capture the beauty of the region, the waterfalls, forests, and prairies around the Illinois River and the young city along the Chicago River.

With large, bulky cameras, they followed canal workers during the last years of the nineteenth century to record construction. Then they spent the first three decades of the twentieth century photographing city streets and farm fields to create a record that would be used in lawsuits filed by those whose lives were changed by the canal. The pictures show intended and unintended consequences. They show the city reborn and the bottomland forests that were destroyed. They show a metropolis on the verge of adulthood and rural landscapes long gone. Paired with the detailed field books, the photographs reveal a side of Chicago few have ever seen: a city still soiled by the prairie but poised for greatness. The photographers weren't shooting the city's grand boulevards or its architectural treasures for stereoviews. Here was a Chicago of cranky swing bridges, crumbling streets, flour mills, warped houseboats, and animal blood oozing into the river. It was a Chicago before the Burnham Plan.

Chicago in the late 1800s was at the center of the world. The century's fastest-growing city, it rebounded with phenomenal speed after being devastated by the Great Chicago Fire of 1871. People flocked to it in the 1880s to see if the city's new skyscrapers would topple, and journeyed there in the 1890s to be enveloped in the magical White City that was the World's Columbian Exposition. "Chicago revels in the stupendous," wrote a *New York Times* reporter in 1895. "It matters not so much what the thing may

be, if only it be colossal."

And most colossal was Ossian Guthrie's drainage canal, whose size and scope captured America's imagination. In 1895, the *Times* declared that the canal was the greatest public enterprise in progress in the United States, and probably in the world. The writer Theodore Dreiser called it an "imperial highway." On one level, it encouraged people to dream. On another, it paved the way for even more monumental projects, including the Panama Canal, which soon shrank the world.

But this is not a book of nostalgia. The canal that Chicago built is still very much with us, linking the city and the Illinois Valley to much of America. The limestone walls that were constructed in the 1890s still form the rim of the canal. The sluice gates that determine the flow are still in place. Dispatchers now decide when to send water into the Des Plaines and Illinois Rivers and whether to release floodwater into Lake Michigan. The project, once dismissed as wildly impractical, continues to be lauded and questioned. Serious studies are now underway to determine if the watersheds should be separated once again, and the Chicago River routed back into Lake Michigan.

In the late 1880s, Chicago's leaders saw the canal as the only way to eradicate cholera, typhoid fever, and other deadly waterborne diseases that plagued the city's one million residents. With absolute willfulness and determination, these leaders remolded the geography of the region. "Chicago appears at its best in an enterprise like this," the *Times* reporter wrote. "The men who have it in the charges are typical Chicagoans—men of enterprise rather than of education—of action rather than culture. Their faith in their own powers is of the kind that literally moves mountains." ⚓

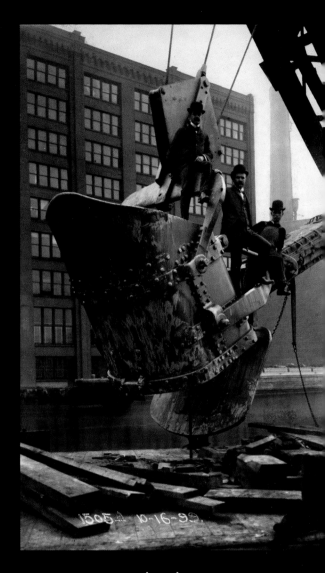

GEORGE M. WISNER (LEFT), WHO BECAME CHIEF ENGINEER OF THE SANITARY DISTRICT, AND WILLIAM LYDON (CENTER), PRESIDENT OF GREAT LAKES DREDGE AND DOCK COMPANY, POSE IN 1899 WITH ANOTHER MAN IN THE DIPPER OF A BARGE-MOUNTED POWER SHOVEL IN DOWNTOWN CHICAGO.

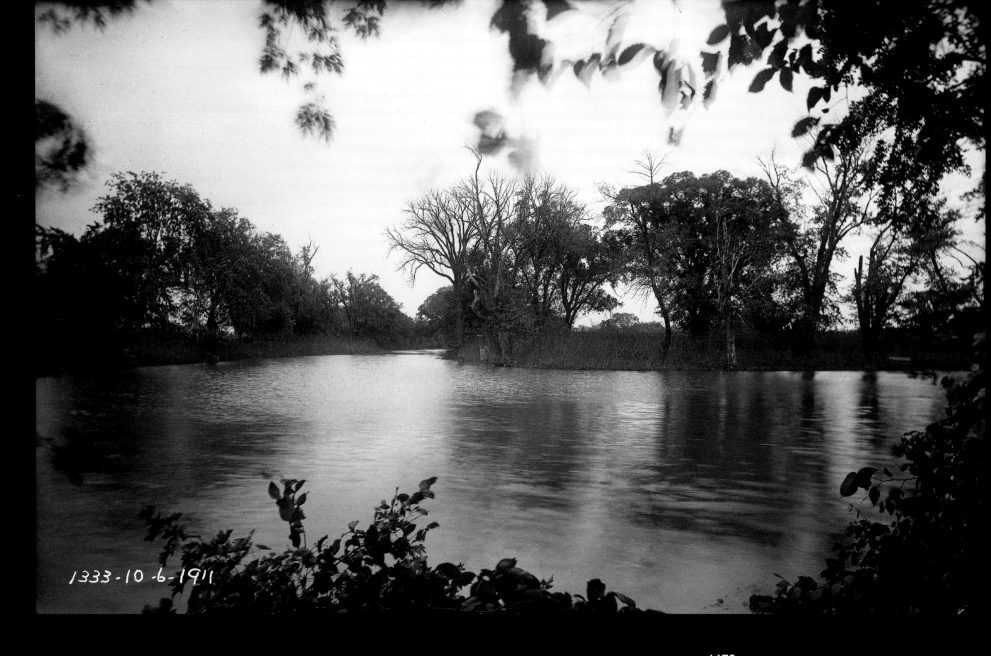

1333-10-6-1911

THE VIEW THAT LOUIS JOLLIET AND JACQUES MARQUETTE HAD AS THEY PADDLED UP THE ILLINOIS RIVER IN 1673. THIS IS THE MAZON RIVER NEAR THE JUNCTION OF THE ILLINOIS RIVER IN PRESENT DAY GRUNDY COUNTY. PHOTOGRAPHERS ETCHED A FILE NUMBER AND THE DATE ON MOST GLASS-PLATE NEGATIVES.

The works of man are mere distortions compared with those of nature.

—Patrick Shirreff,
A Tour Through North America, 1833

There is a tiny rise, not a hill or even a ridge, about ten miles southwest of downtown Chicago that once stopped the waters of the Great Lakes from flowing toward the Gulf of Mexico. It is an incredibly low continental divide, only a couple of feet high, but it does indeed split the watersheds of the Atlantic Ocean and the Gulf, sending water in opposite directions. The rise, which has no official name but is known among geologists as one of the lake border moraines, was formed several thousand years ago when Lake Chicago, a small prehistoric lake created by huge glaciers receding north, gradually expanded into Lake Michigan, assuming its present size and shape. It is the result of a million-year geologic battle between ice, wind, water, and stone that ended in a draw.

Don't search for the rise; no trace of it remains. It has been swallowed up by highways, shopping centers, parks, playgrounds, and homes on Chicago's Southwest Side and in suburbs like Summit (named for the slope), Hickory Hills, and Palos Heights. Nobody knows exactly where it is. Topographic maps are not detailed enough to specify the rise, and experts debate its exact location. Even the region's earliest inhabitants probably could not have seen the slight ridge as they dragged their birch-bark canoes a mile or so along the wet grassland that separated the Chicago and Des Plaines Rivers. But they would have sensed it as the waters grew shallow and dried up in the swampy area between the two rivers known as Mud Lake.

This portage—sometimes half a mile long and sometimes a few miles long, depending on conditions—was a favored spot of Native Americans who used Mud Lake as a shortcut to Lake Michigan. They showed the bypass to the French explorers Louis Jolliet and Jacques Marquette, whom they met paddling upstream in 1673. Chicago can trace its origins to that chance encounter.

~ ~ ~

LOUIS JOLLIET AND JACQUES MARQUETTE set out with two canoes and five voyageurs from the tip of Michigan's Lower Peninsula to survey what the Ojibwa called the Misi-ziibi, or Great River. Jolliet, who was seeking a route to California, was the perfect wayfarer, for he knew Native American dialects and was skilled in hydrology, mapmaking, and woodworking. Wrote a biographer: "He has courage to dread nothing where everything is to be feared." Marquette, a Jesuit priest, was seeking the salvation of souls. He wanted to introduce Christianity to the natives. After exploring more than a thousand miles of the Mississippi, from Wisconsin to Arkansas, the two men realized that the river emptied not into the Pacific Ocean but the Gulf of Mexico, so they turned back.

On their return, against the current, the explorers came to the mouth of the Illinois River. They were astonished at what they saw as they crossed the prairie on a diagonal route from the Mississippi toward Lake Michigan. "We have seen nothing like the river that we enter, as regards its fertility of soils, its prairies, and woods; its cattle, elk, deer, wildcats, bustards, swans, ducks, parroquets, and even beaver," wrote Marquette. Jolliet, who called the river *Les Divines*, was intrigued by the area's potential. "When I was told of a country without trees," he wrote, "I imagined a country that had been burned over, or of a soil too poor to produce anything; but we have remarked just the contrary, and it would be impossible to find a better soil for grain, for vines, or any fruits whatever." Jolliet figured that the prairie was a perfect place to create a colony: "On the day of his arrival the emigrant could put the plough into the earth."

But what interested Jolliet most was a patch of land at the southwestern edge of Lake Michigan. As he and his crew paddled upstream on the Illinois River, then onto the Des Plaines, and slid their canoes through a short portage among the weeds to the South Branch of the Chicago River and out into Lake Michigan, Jolliet saw an inner passage that could open the entire country. "We could easily sail a ship to Florida," he wrote. "All that needs to be done is to dig a canal through half a league (less than two miles) of prairie from the lower end of Lake Michigan to the River of St. Louis (the Illinois River)."

Jolliet never returned to the portage or the area that became known as Chicago. His rival, the French explorer René-Robert Cavelier, Sieur de La Salle, downplayed Jolliet's "proposed ditch," likely because La Salle was jealous of Jolliet's find and because La Salle's several experiences passing through the portage were all much more difficult than Jolliet's had been. But La Salle admitted that "Le Portage de Checagou" was the perfect embarkation for points west. "This will be the gate of empire," he wrote.

The region did turn out to be ideal for settlers. But Jolliet's canal was put on hold because of constant and traumatic changes. Indian wars were frequent, and empires fought for the land. During the next century or so, Illinois was controlled by Indians, France, Britain, the Commonwealth of Virginia, and the United States. By 1818, the year of Illinois's statehood, there was persistent talk about creating the canal that Jolliet had envisioned. At that time, canals were the most promising form of transportation.

Almost all Americans in those days lived local, using whatever resources they had at hand. Log cabins were built with area timber; pioneers harvested their own food. Cross-country canals—with their craggy towpaths, miter gates, and picturesque limestone banks—might seem like a romantic vestige of rural America now, but they once represented progress as America's great highways. Starting in the early 1800s, canals dramatically cut the cost of moving heavy goods, offering an alternative to the wooden wagons pulled by oxen and horses on primitive paths. Canals opened new markets, making it possible for merchandise to be manufactured and sold in different parts of the country. The success of the ambitious Erie Canal, which joined Lake Erie to the Hudson River across New York state, spurred a canal-building boom that connected America's farms and rural industries to emerging cities. By 1825, most every large U.S. city—New York, Philadelphia, Boston, Harrisburg, Pittsburgh, Cleveland, Cincinnati and Louisville—boasted a national waterway that linked it to the interior. And most every state that paid for the canals nearly went bankrupt.

It is no surprise, then, that Illinois moved so slowly in building its canal. The federal government of the new nation encouraged the construction of and set aside land for canals, but it did not pay for them. In 1822, Congress gave Illinois the authority to build a canal that would link Lake Michigan to the Illinois River and do away with the portage, but the project floundered. Surveys were completed, budgets were prepared, and commissions were established, but the state could not come up with funds sufficient to start work. The federal government permitted the state to sell public land along the proposed canal route, but the land did not prove suitably valuable. Commissioners finally raised enough to begin construction on July 4, 1836, but money remained a problem. The Panic of 1837 stopped work. Four years later, the state printed script to bring the project back to life, but the script lost most of its value.

Canal work—done with shovels and wheelbarrows in surprisingly rocky soil from sunrise to sunset—was low paying and backbreaking. Contractors had trouble attracting locals and so recruited Irish, German, and English immigrants. Original plans called for the Chicago River to be drawn directly into a deep canal below the level of Lake Michigan. But when money got tight, revised plans called for a shallow canal just six feet deep and sixty feet wide. The Illinois and Michigan Canal (named for the river and the lake) finally opened in 1848.

Jolliet's declaration that a canal needed to be only a mile or two long was ridiculously optimistic. Crossing the portage in low water might mean carrying boats overland for five or ten miles. The I&M Canal started at a prairie outpost called Hardscrabble on the South Branch of the Chicago River in what would become the Chicago neighborhood of Bridgeport and meandered ninety-six miles southwest to another prairie outpost called LaSalle (named for La Salle) on the Illinois River. The first boat that trundled up the I&M from LaSalle to Chicago in the spring of 1848 reached Buffalo, New York, with a cargo of sugar one week later. The I&M moved grain, molasses, cotton, sugar, and tobacco from the South, lumber from Michigan, flour and salt from the East, and quarry stone that was mined along the route. It helped create the Board of Trade, and made Chicago the transportation hub of America. The city's population skyrocketed from fewer than five thousand in 1840 to one million in 1890.

~ ~ ~

FROM THE START, Chicago was blessed by its location at the calm southwestern corner of Lake Michigan. It was in the heart of what is now the Corn Belt, near the eastern edge of wheat fields, just south of deep forests and north of rich coalfields. Bordered by the lake, it was defined by the Chicago River, which heads straight west from the lake before separating into the North and South Branches. The river divides the city into three sections—North Side, South Side, and West Side—which were much more distinct before bridges were built.

The city's primary advantage has always been its supply of clean lake water. Chicago is one of the largest cities in the world with abundant access to near-pure drinking water. "For in all my lifetime, I never saw a place

where nature has done so much," noted a Mrs. R. G. Hamilton in 1833. Wrote G. P. Brown later in the century: "Nature has fairly lifted the cup to Chicago's lips."

Surprisingly, the city's early inhabitants got their drinking water from wells they sank on their property, on vacant lots, and in the streets. Dishwater, wash water, kitchen refuse, privy waste, and underground clay contaminated the wells, which led to periodic outbreaks of cholera and typhoid.

By midcentury, Chicagoans turned to the lake for water. Private companies backed huge hogshead casks into the lake, placed them on wagons, and drove down city streets selling water by the barrel. The Chicago Hydraulic Company established a mill and waterworks along Lake Michigan, drawing water from cast-iron pipes in the lake and storing it in enormous reservoirs, one in each of the city's three main sections. But the lake water started tasting bad, too, primarily because offal from South Side stockyards and waste from North Side distilleries and factories were dumped into the Chicago River.

The city knew early on that it must protect its source of clean drinking water. Cholera, a disease spread by contaminated water that could kill a person within a day, was rampant during the 1850s, so the city took action by hiring Ellis Sylvester Chesbrough, the most competent engineer of the age. Bushy-bearded Chesbrough, who would guide Chicago's waterworks and sanitation system for the next two decades, was a thinker and a doer. He immediately suggested raising the grade of Chicago's streets about ten feet so that a comprehensive sewer system, the nation's first, could be built. It almost sounds like folklore, but with Chesbrough in charge, the city lifted itself out of the muck by literally jacking up its buildings to meet the new street level. Large mains beneath alternate streets replaced the underground vaults that had stored sewage and filled Chicago's streets with garbage and slime. But Chesbrough's new sewer lines did not solve everything: they all led to the Chicago River and Lake Michigan.

To figure out an answer, Chesbrough sailed to Europe on what was perhaps the least elegant grand tour in history. He visited sewage farms and checked out clay pipes, circular brick sewers, and flush toilets as he studied waste management in Manchester, London, Amsterdam, Hamburg, Berlin, Paris, Glasgow, and six other cities. He returned with plans to greatly extend the underground sewer system and to freshen and deodorize the polluted North and South Branches of the Chicago River. But the country's longest and most complex sewer system was not enough to keep the lake clean. The underground pipes pumped more and more sewage into the river and lake as the city grew.

So Chesbrough came up with a new plan. He would locate the city's intake crib, where it drew its drinking water, two miles into Lake Michigan and connect it to the city's waterworks with a pipe built inside a sloping brick tunnel thirty feet under the lakebed. One team of workers started at the lakeshore, and another team at the crib. They met midway, only seven inches apart.

"When Mr. Chesbrough reported the feasibility of the tunnel, the Board of Public Works, as well as public sentiment, were full of doubts and misgivings," wrote a contemporary biographer. "The conservatives of science were incredulous; the conservatives of finance raised a sullen growl . . . while even the public-spirited and progressive were jocose at the expense of the 'unprecedented bore.' But the City Engineer had too firm a hold on public confidence, and too secure a place in the confidence of scientific circles, to be shaken from his position or a newspaper jest. He silenced both by the success of his undertaking. That success has made him famous."

Chicago's mayor, John B. Rice, declared Chesbrough's crib and lake tunnel "the wonder of America and the world." The *Chicago Times* editor Wilbur Storey wrote: "We have the purest water in the world. . . . We have tapped the lake at a point where exists only ever-lasting purity."

But the solution was only temporary.

Chesbrough knew that the only logical fix was to send Chicago's sewage away from the lake—but the cost seemed prohibitive. On his trip to Europe, he seriously considered the idea of deepening and enlarging the I&M Canal so that it could pull some of the dirty water of the Chicago River west and, in a sense, reverse the flow of the river away from the lake. The idea of enlarging the canal was spurred by the Civil War, as the nation's leaders saw the benefit of moving larger boats and more war supplies through Chicago. A bigger canal would be particularly important, the *Chicago Tribune* editorialized in 1862, if the British joined the Confederate cause.

That same year, a pump was installed at the head house of the I&M Canal in Bridgeport to flush some water from the Chicago River down the canal during dry periods. With it

went Chicago's sewage. "Glorious News from Bridgeport: The River Filth Going to the Rebels," proclaimed a *Tribune* headline. "All those who are desirous of taking a parting sniff at the Chicago River perfume, would do well to visit Bridgeport today, as at the present rate of progress, all the filth in the river will, in a day or two, be on its way to the rebels." Although treated lightly in this squib, the event was momentous, marking the first time Chicago sewage was sent toward the Illinois River instead of Lake Michigan. Chicago's decision to pay the canal commissioners to pump about a hundred million gallons of river water down the I&M Canal was the opening act in a drama that was to last through the end of the century. All of a sudden, Chicago had a solution to its sewage problem.

~ ~ ~

DESPITE THE RELIEF VALVE that the I&M Canal now provided, conditions along the Chicago River grew more serious. As city factories hustled to keep up with the demands of the Civil War, the river was becoming increasingly polluted. "The filthy condition of the Chicago River has long enough been a staple of conversation in our city, rivaling even that other standing topic—the weather," the *Tribune* said in 1864. "All the talk and writing, and inspection, and legislation yet done seem to have effected no good. Yet something must be done; before long the mischief must be met and the foe conquered, or there will be no people left to grumble."

A week later, the *Tribune* sent a reporter to check out the North Branch, where distilleries were dumping their waste directly into the river. "The Chicago River is a curious institution,"

he wrote. "It is a paradox; we live by it, and it will yet be the death of us." Worse were the stockyards on the South Branch and the other factories lining the river that produced pork, lard, grease, beef, tallow, iron, and animal oil—exports of Chicago. "The air blowing from the region of Bridgeport is well known to be pregnant with erysipelatous and other disease, and the air and water from the North Branch—we cannot tell," a reporter stated in 1864. "Let any one travel along the Milwaukee Railroad, when the wind is blowing from the lake, and feel for himself how the stench enters his nostrils in the vicinity of the distilleries: then let him pay a visit to the numerous cabins which are found there, and see the tenants vomit now and again when a passing vessel stirs up the waters; he will need no other description."

Some relief came in 1865 when the state approved a plan to enlarge and deepen a section of the I&M Canal between Chicago and Lockport. This was where the slight land rise in the village of Summit, just west of Chicago, slowed the flow of water. By removing the ridge and cutting deeper, the elevation of the canal would remain completely below that of the Chicago River and the canal would function like a downspout in drawing river water as originally planned.

Many towns down the Illinois River protested that the deeper canal would simply bring more sewage their way. They understandably did not welcome the prospect of their river receiving more of Chicago's waste. But one paper at least, the *Peoria Transcript*, lauded the effort, saying the new I&M Canal would bring fresh water, a new source of power, and "sanitary blessings" to

the state. "No sooner was the plan broached," wrote the editors, "than an attempt was made to laugh it down, and finding that unsuccessful, the old cry of pestilence is raised, the last resort of wooden-headed conservatives who have greeted every invention from the rail car to the cooking stove by dismal forebodings of disease and sickness that were to follow their introduction. Chicago is as likely to poison the Illinois River and breed a pestilence in the state as London to poison the Thames; Paris, the Seine; New York City, the Hudson; St. Louis, the Mississippi."

It took six years to complete the deep cut, and the results at first seemed promising. When improvements were finished, Chesbrough observed that a strong current was created and the South Branch became "quite clear and entirely free of noxious odors." But it soon became apparent that the canal could not keep up with new problems. By the 1870s, millions of animals were being slaughtered in packinghouses along the Chicago River, and their remains were tossed into the water. Meanwhile, the privately built Ogden-Wentworth ditch was working against the I&M Canal, depositing sediment into the I&M Canal and polluted rainwater from the Des Plaines River back into the Chicago River during heavy rains. And in 1871, the Great Chicago Fire turned the attention of city leaders to more pressing concerns.

~ ~ ~

THREE ORGANIZATIONS WERE FORMED during the 1880s to find an answer to Chicago's sewage problem. All three came to the same conclusion: they called for the construction of a "New

River," an artificial waterway that would send the city's sewage westward. The groups placed their faith in a logical but unproven concept called "self-purification." They were convinced that if sewage was left long enough in a moving stream, it would break down and become clean by the processes of oxidation and dilution. Their mantra: "The solution to pollution is dilution." Leading the charge was Rudolph Hering, a renowned engineer who had taken part in designing water systems in New York, Washington, D.C., and Mexico City. But another key player was Ossian Guthrie, the genius and crank whom Ellis Chesbrough and others later credited as being the father of the new canal.

Guthrie arrived in Chicago in 1846, at about age twenty, and built the steam engine for the first tug that plied the Chicago River. In 1847, he started keeping a daily log of the fluctuating levels of Lake Michigan, a record that helped convince public officials that siphoning Lake Michigan water to freshen the new canal would have little effect on lake levels. Around 1849, he started work as a mechanic at Bridgeport's pump house, and later served as chief engineer. Chesbrough talked in passing about the creation of a sanitary canal, but it was Guthrie who was the first to push for it. He used news of the severe cholera epidemics in Europe to get Chicagoans to care about the issue and cited chemical tests to show that sewage was reaching the intake valve. He and others lobbied legislators in Springfield and wrote letters to newspapers pressuring politicians and speaking out for the creation of a new sanitary commission that could tax and borrow money to build the Big Ditch.

Building a bigger, better canal appeared to be Chicago's only option. The city was growing at breakneck speed, and typhoid fever, another deadly waterborne disease, gripped the city during the 1880s. To help clean its river, the city pumped more and more water from it into the brimming canal, but people downstream began to take notice. "Ever since the water from the Chicago River was let down the Illinois River, the stench has been almost unendurable," wrote a resident of Morris, a river town sixty miles southwest of Chicago. "What right has Chicago to pour its filth down into what was before a sweet and clean river?"

It was a good question. What began as a temporary solution to reduce the stench of the Chicago River in the 1860s had grown into a "nuisance," as Chicagoans blithely referred to it, for those who lived near the I&M Canal and downstream along the Des Plaines and Illinois Rivers. Fish were dying, decay was forming along the banks, water wheels were clogged with sewage, and the stench was brutal.

So it might have seemed remarkable that Chicago had the gall to propose a bill in the state legislature in 1886 for a deeper and wider canal to carry its sewage to the Des Plaines and Illinois Rivers. Chicago promoters argued that the new canal would be beneficial for downstate river towns because, with its large amount of fresh Lake Michigan water, it would be noticeably cleaner than the I&M Canal and could be used by boats. Proper dilution would make the sewage "harmless and inoffensive." But the downstaters knew that the new canal could open the floodgates to even more sewage from their gargantuan neighbor. Eventually Peoria, LaSalle, Morris, Ottawa, Peru, Lockport,

Seneca, Marseilles, and Joliet all passed resolutions against the canal.

The loudest opponent was the city of Joliet, about forty miles downriver. In 1887, five members of Joliet's Business-Men's Association, including its chairman, J. D. Paige, traveled to Chicago to meet with Mayor Carter Harrison Sr. and Rudolph Hering, the technical mastermind behind the canal. The businessmen were assured that the new canal would be much less offensive than the Illinois and Michigan Canal and would be deep and calm enough to bring steamers from as far away as St. Paul, Minnesota.

"Then a brilliant idea struck Mr. Paige," the *Tribune* reported, "and he threw this stunner at the Mayor: 'Who will guarantee purity of water? What is to prevent the powers that be from abandoning the work as soon as Chicago is relieved of its sewage?'"

The response was typically paternalistic.

"Why it's like this," the Mayor said. "Whatever is done will only temporarily relieve Chicago, while it leaves you better off than you are now. But when Chicago gets to have a million and a half of people (its sewage) will have to be carried out or the city must die."

In other words, Chicago would always pay for the canal because it would always need it. The businessmen were not moved. They joined the Joliet City Council to work against the passage of a bill in the state legislature that would set up a commission to build the new canal. The issue was clear to Paige, who was elected mayor of Joliet soon after the Chicago meeting. The I&M Canal had demonstrated that Joliet sat in a particularly vulnerable location because it was there that Chicago's

sewage started to putrefy. As was confirmed by biologists, the sewage in the I&M Canal didn't stink as much flowing through Chicago as it did downstream, a particularly nice perk for Chicago. Paige also knew that a bigger canal meant not only more Lake Michigan water but more Chicago sewage as well.

Not unexpectedly, Chicago newspapers never acknowledged the case made by Joliet and other river towns opposed to the canal. Townspeople were labeled "Illinois Valley extremists" and bullied in editorials. "Here comes the hue and cry about contaminating the waters of the Illinois Valley and spreading disease and death all along its course," proclaimed the *Tribune*. "That be so, then why in the name of God have not the whole population of Chicago died long ago from pestilence, who have been subjected to the concentrated contamination of this sewage for thirty years and more! Let us look at this thing in a common sense way, and not after the manner of scientific idiots."

The 1.1 million people in Chicago prevailed over the 330,000 who lived along the Illinois River. When the Illinois House and Senate approved the bill that chartered the Sanitary District of Chicago in 1889, the *Joliet Republic and Sun* suspected it was not passed on its merits: "Every vote cast for this corrupt measure was traded for or bought." Even the *Tribune* expressed surprise: "There was a wild scene of disorder when the Speaker announced that the bill had passed."

The original Sanitary District of Chicago, which served an area bounded by Lake Michigan, Harlem Avenue, Devon Avenue, and Eighty-Seventh Street, was a new kind of taxing body that had police authority and the power of eminent domain. The nine members of its board of trustees, who won their seats in a general election, held their first meeting in early 1890. But little progress was made during the district's early years. Four trustees, three chief engineers, three chief attorneys, a clerk, a secretary, and a treasurer all resigned as the board argued about routes and dealt with soaring costs. At one point, the board even considered simply enlarging the Illinois and Michigan Canal or spending its tax money on building a railroad line.

In the face of this retrenchment, the district's first chief engineer, Lyman E. Cooley, stalled as he waited for the political winds to change. Cooley, who served with Ossian Guthrie on the Citizens' Association, recoiled at the idea that the canal might be a glorified drainage ditch. He shared the explorer Jolliet's vision of a glorious shipping link between the Great Lakes and the Gulf of Mexico, and he had promised downstaters that the canal would be a blessing to their towns. So Cooley bought time by setting up gauge stations and testing ground soil. When the trustees grew angry, he was forced to resign his job, but he soon won election to the board himself.

Two years into the project, the wrangling stopped. The public demanded the board of trustees get to work, and work proceeded at a furious pace. Somehow Cooley's ambitious plans prevailed, and in 1892 a route was chosen, bids were opened, and contracts were awarded. Engineers were hired for their competency rather than their connections—very unusual in a city with a reputation for boodling public officials. "The question of a man's politics is never brought up," declared Frank Wenter, the district's new president. Even the *New York Times* noticed the change, admiringly comparing the board to the group that miraculously put together the World's Columbian Exposition in a few years: "These two great enterprises are brilliant examples of what a civic enterprise can be if the professional politician is kept out of it, and if it is run on the same business principles that govern a railroad or manufacturing company."

Soon after the twenty-eight-mile route was chosen, land was purchased for the canal that connected the South Branch of the Chicago River at Robey Street (now Damen Avenue) to downstate Lockport, where a controlling works would be built to regulate the amount of water in the canal and control the flow of water into the Des Plaines River. The Big Ditch ran close to the Illinois and Michigan Canal, often mirroring the route of the old canal just a few hundred feet to the north and west. For much of its stretch, it was slipped between the old canal and the Des Plaines River.

On September 3, 1892, upward of twelve hundred people traveled to a spot on the border of Cook and Will Counties just west of Lemont to witness the start of work on the canal at a formal ceremony known as Shovel Day. A snapshot of the event shows the speakers' platform draped in flags and bunting. White lines were painted in front of it marking the exact middle point of the canal and where the banks would be dug. Newspapers compared the event to the ceremonial driving of the golden spike at Promontory, Utah, but the affair at Lemont turned out to be more of a carnival. Vendors sold ice cream, spruce beer, pop,

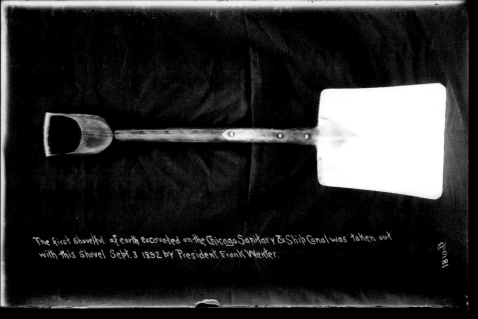

The first shovelful of earth excavated on the Chicago Sanitary & Ship Canal was taken out with this shovel Sept. 3 1892 by President Frank Wenter.

ONE OF THE SHOVELS USED ON SHOVEL DAY, 1892

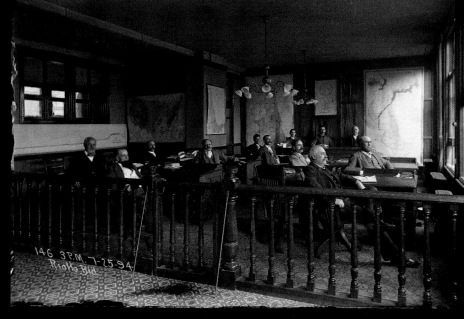

146 3 P.M. 7-25-94
Rialto Bld

SANITARY DISTRICT TRUSTEES AT THE RIALTO BUILDING, 1894

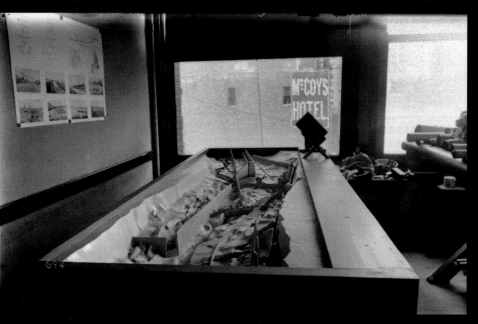

DISTRICT MODEL OF RIVER VALLEY, 1895 OR 1896

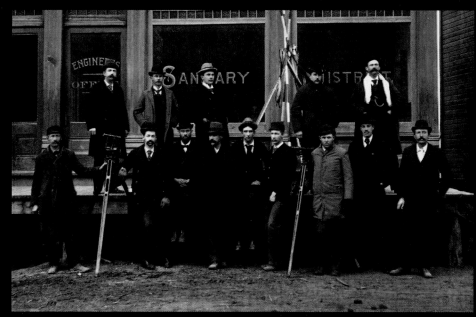

ENGINEERS' OFFICE IN LEMONT

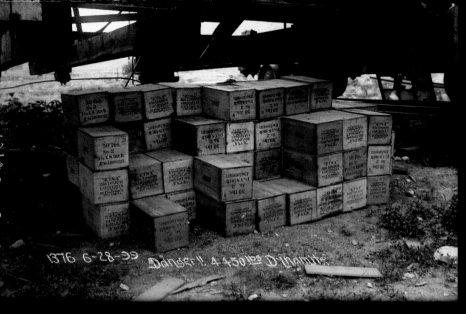

BOXES OF STORED DYNAMITE, 1899

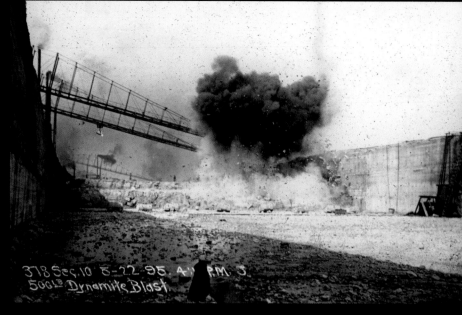

EXPLOSION NEAR LEMONT, 1895

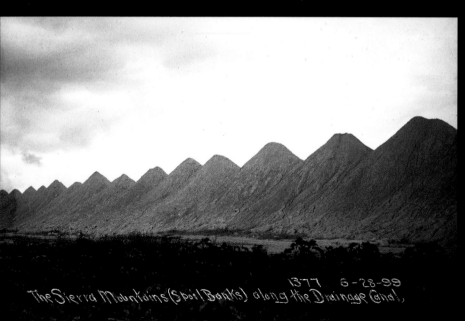

SPOIL BANKS ON THE SIDE OF CANAL, 1899

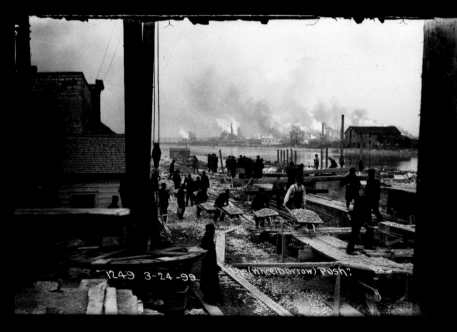

LAST-MINUTE WORK IN JOLIET, 1899

watermelon, peanuts, and popcorn; gamblers took bets on a wheel of fortune and ring-toss games. The *Tribune* could not pass up the chance to point out the differences between the "Chicago men," who traveled to the site on eight train coaches in a moving stag party, and the "solid farmers" of the Des Plaines River valley, who came with their families in wagons, on horseback, or by foot. "There were pretty valley lassies, too, wearing suspenders and other modern improvements in feminine apparel," one reporter noted.

In spite of those feminine touches, the ceremony was all male. When President Wenter of the Sanitary District straddled the county line with his nickel-plated shovel for the first scoop, Mayor Harrison shouted, "Stick it in deep, Frank." The crowd, which had been especially quiet, let out a huge cheer, roared with applause, and frantically waved their handkerchiefs. Then Lyman Cooley, who had designed the final route, declared that the construction of the new canal was a divine right: "Man's creative intelligence can remedy nature's caprice, restore the ancient outlet; and even more, extend through the continent from fog bank to tropic breeze, as though it were the sea, joining coast, lake, and river systems in one whole, as it is not possible elsewhere on earth." He then flipped an electric switch that detonated dynamite on two rock piles, one on each end of the crowd.

"The blast had riven the solid rock under the soil and filled the air with its fragments," the *Tribune* reported. "Earth and rock had alike given way to the prowess of man in the preliminary ceremonies of the great undertaking." The men from Chicago started

running toward the explosion to be the first on the scene, but a Will County resident on a yellow horse outdistanced them all to pick up the first rock that fell. "All the others, however, secured fragmentary mementos of the attack on mother earth and bore them proudly away. The wire used in causing the explosion was cut into small pieces and carried away by relic hunters."

~ ~ ~

EVEN BEFORE THE FIRST SPADE was turned, the Sanitary District had seriously considered photographing the entire route of its new canal. Trustee Cooley proposed it in 1892, but his idea was ignored until the next year, when the board passed an order directing the chief engineer to photograph the Main Channel, the more formal name of the Drainage Canal. Although the board's proceedings seldom mention photography, monthly budgets from early 1894 hint at progress. The first item was an $88 bill marked "Chicago Engraving Company (engravings for history)." Invoices soon followed for dry plates, negative holders, pans, racks, tanks, trays, and mounting supplies. A "photographic outfit" was requisitioned shortly after.

The Sanitary District also hired a small staff of photographers, who worked under the direction of district engineers. The district's first photographer was William M. Christie, whose copyright stamp boasted that he possessed "the most complete collection of Chicago Drainage Canal views." Born to a western New York farm family in 1864, Christie moved in the early 1890s to Lemont, where he worked as a surveyor and civil engineer. It is not clear how much photo experience he brought to the job, but he took competent pictures from

the start and was not hesitant to experiment with the technology of the day.

Christie took his first photos of canal construction on May 28, 1894. He carefully noted his locations and the atmospheric conditions and recorded the type of lens he was using (Beck's wide-angle Autograph series), the lens opening (f/128), the brand of dry plates (Cramer C), and the chemicals for intensifying the image (platinum salts). He took twenty-four shots during the first four days. Christie approached the project with a civil engineer's view. He worked efficiently and documented just what he saw, eventually taking about a thousand pictures between 1894 and 1900 and leaving a complete written record of each. By 1900, Christie was in charge of the engineering department's record photography division. He had a bit of help from Carlton R. Dart, another engineer, in 1897 and B. E. Grant in 1898, but Christie took almost every photo during the project's first decade.

Photography was seen as an aid to construction. "The Sanitary District of Chicago has an engineer especially appointed to keep a record set of photographs of the progress of the contractors on the channel, and he does nothing else as I am given to understand," wrote the civil engineer John W. Alvord in an 1895 report to the Illinois Society of Engineers and Surveyors. "If so, the trustees are to be congratulated in avoiding the mistake made in the construction of the World's Columbian Exposition, where this work was unfortunately in the hands of an official photographer, and the result while interesting perhaps from an artistic standpoint, was of no value or assistance to the engineering department upon that work."

In his report, Alvord offered tips to engineers that give a sense of how photographers worked back then. First, he recommended a good tripod camera: "A six-by-eight-inch camera with its extra plate holders and other accessories is about as heavy and bulky as is desirable for one man to carry with convenience. Eight-by-ten and ten-by-twelve sizes will burden even the man used to shouldering the transit." The dimensions Alvord mentions were the dimensions in inches of the glass-plate negatives. Christie and the other district photographers usually used cameras that accommodated five-by-seven-inch negatives. Photographers of that era generally printed photographs to the exact size of their negatives because enlargers were not in common use. The five-by-seven-inch camera was small enough to be agile and big enough to produce large images that could be printed with fine detail. "This gives an excellent size for carefully studied pictures of construction work, landscape, machinery or for reports and is perhaps the most useful size, all things considered, that the engineer can adopt," Alvord observed.

~ ~ ~

OSSIAN GUTHRIE, who attended the groundbreaking, was pleased with the early work. Six weeks after the ceremony, he said he was surprised by the low cost of most of the contracts. After touring the site, he said: "To say that I am satisfied with the plan as a whole and with the progress of the work is not enough to convey my idea. One must see the work to appreciate it."

Construction of the canal, which sloped less than six feet from Chicago to Lockport,

was divided into three parts: a 7.8-mile earth segment from Robey Street to the village of Summit, a 5.3-mile earth-and-rock segment from Summit to the village of Willow Springs, and a 14.9-mile rock segment from Willow Springs to Lockport. Land along the earth segment, the eastern stretch of the canal, was made up primarily of glacial drift—topsoil, muck, sand, gravel, clay, hardpan, and the occasional rock or boulder, the kind of ground that most characterizes the Prairie State. The earth-and-rock segment, in the middle of the canal, was made up of glacial drift and rocks. The rock section, on the western side, was primarily limestone, the kind of rock used to build Chicago's Water Tower.

Twenty-nine contracts were chosen for the twenty-eight-mile canal, so each contractor was responsible for about a one-mile stretch, unless the contractor worked on more than one section. Each faced two major challenges: excavating the earth to the exact dimensions of the canal and removing the blasted rock material. On the earth sections, contractors often used horse-pulled plows and scrapers to strip off the topsoil. Removal of the dirt was done the old-fashioned way, with men pushing wheelbarrows. Steam shovels were brought in to break up and remove the layers under the topsoil. To soften the earth before the steam shovels began work, contractors used dynamite, which could be heard all the way back to Chicago if the wind was blowing northeasterly. The material dug out of the canal within Chicago's city limits was hauled away by train. Some was used as landfill to build Lakefront Park, the forerunner of Grant Park. Some was placed on lake barges and dumped far from shore.

On the more difficult earth-and-rock and rock sections, contractors relied on channeling machines to dig thin, smooth grooves down into the rock. The grooves created air shafts that stopped the percussive effect of the dynamite. The channelers, which were fairly new in the 1890s, made it possible for workers to control with remarkable precision which rocks were blown away, creating almost perfect walls. Following blasts, laborers used pickaxes to cut blasted rocks and boulders into smaller pieces and then brute strength to haul the material to horse wagons, donkey carts, hoists, train cars, trolleys, and conveyor belts to be carried off to the tall mountains of spoil on both sides of the canal. The use of dynamite—with fulminating caps and fuses and electricity—was essential to get the work done at a reasonable cost. It saved millions of dollars.

In order to survive and turn a profit, contractors knew they needed to reject the old methods of canal building and innovate. "It is probably not too much to say that nowhere at any time in the history of the world have so many novel and different machines for excavation and removing earth and rock been in operation in so small a territory," wrote Charles Shattuck Hill in *Engineering News*. "This was survival of the fittest."

Sanitary District trustees, determined to keep costs down, played tough with contractors. In a rush to start, the district did an inadequate job of studying the makeup of soil along the route and provided misleading information on many bid documents. Contractors complained, but trustees refused to renegotiate. When workers hit rocks in the earth section, at least three contractors sought to readjust their

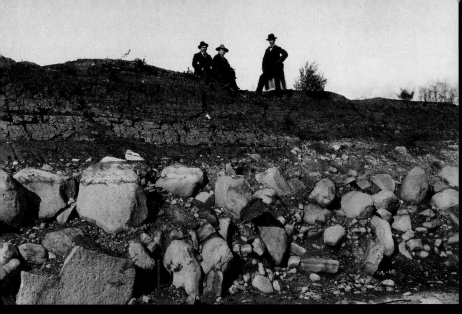

BOULDERS REMOVED FROM EXCAVATION SITE

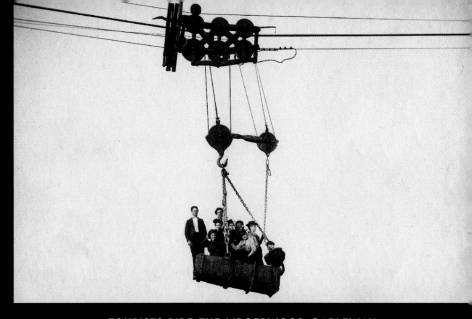

TOURISTS RIDE THE LIDGERWOOD CABLEWAY

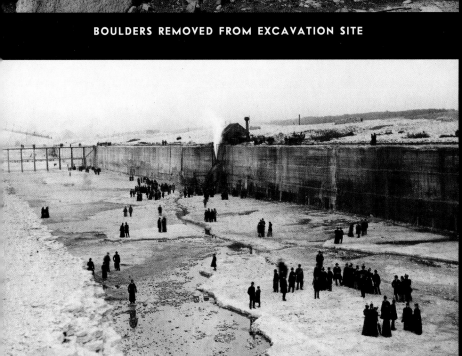

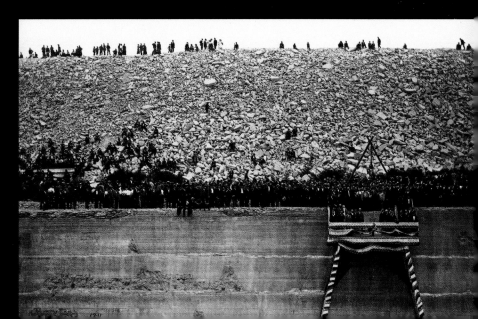

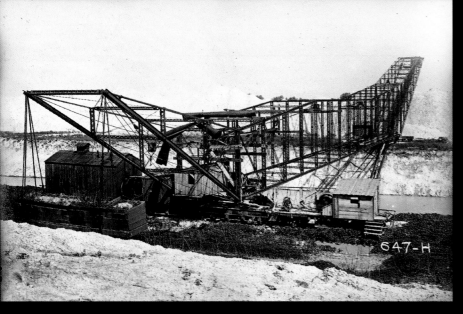

BIGGEST APPARATUS: THE DOUBLE-CANTILEVER CONVEYOR

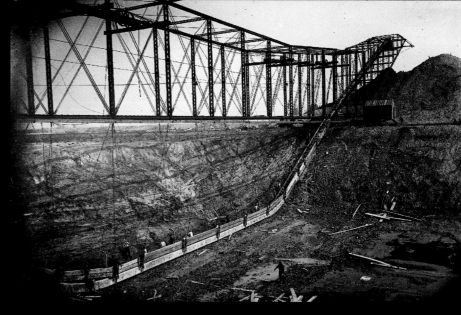

A RUBBER BELT REMOVING MATERIAL RAN UNDERNEATH

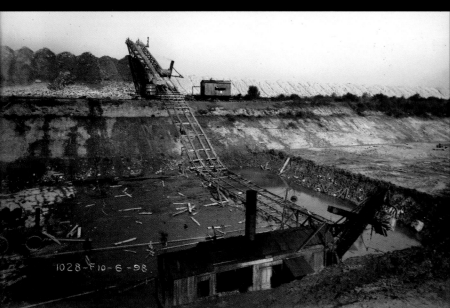

STEAM SHOVEL AND TWO-CAR INCLINE, 1898

A SKIP DUMPS DEBRIS ON SPOIL PILE

contracts, but the district said no in every case.

There were many surprises under the prairie loam—particularly the hard clay deep down. "Frequent boulders were imbedded in the clay, which often sat atop quick sand," Hill reported. "This sand is so soft that a person quickly sinks into it, and is also somewhat viscid; thrusting against it with the foot causes it to shake, jelly-like, for a considerable distance around the point of pressure."

Many firms walked away from their original contracts. Others figured out new ways to finish the work with new machines. E. D. Smith & Company, of nearby Romeoville, was the first to turn the tables, clearing in the range of $75,000 and $200,000 for their sections. "When they took the contract the rates were regarded as ruinously low," the *Tribune* reported, "and yet so rapidly did the science of excavation develop soon afterward that the rate became too high and the profit a handsome one."

~ ~ ~

PEOPLE FROM ALL OVER THE WORLD, including thousands of visitors to the 1893 World's Columbian Exposition, along with thousands of Chicagoans took the morning train to see the construction of the canal. Two train companies produced detailed booklets describing the work. The tourists came to see foremen swear in three languages, huge wheelbarrow gangs, and amazing machinery.

"Some day, when you haven't anything better to do, put on your old clothes and go to the drainage canal," a *Tribune* reporter wrote in 1894. "Nothing could be of greater interest even to one who has no technical knowledge of engineering. You will need your old clothes,

because you want to go into all sorts of places. Your thickened shoes will be in order when it comes to climbing over an acre of jagged rocks."

The best show was the dynamite. Soon after arriving at the canal site near Lemont, the *Tribune* reporter was warned by a foreman to take cover. The reporter relished the choreography of the scene as flying rocks fell all around like hailstones. "It seems that each man has his particular hole he crawls into when the signal for a blast is given," the reporter explained. "There he keeps his pipe, so while he is waiting for the blast to go off he has a quiet hole which his contract with the boss does not provide for."

One visitor was not so lucky. A Chicago man named Edgar Isbell, a popular doorkeeper at the Builders' and Traders' Exchange, was on a group outing when he was struck in the head as he turned to witness a blast. "Friends gathered about the prostrate form of Mr. Isbell, and a slight examination revealed a hole almost round and nearly three inches in diameter just above his right ear," the *Tribune* reported.

Dynamite also made for dramatic pictures. "Our own photographer does not care to take his life in his hands photographing explosions, so keeps at a safe distance," the Sanitary District's chief engineer, Isham Randolph, wrote of William Christie. The photographer actually took several shots of explosions, and carefully noted how many pounds were used in each blast he shot, but he did not get close enough for the boss. "The finest photograph of a blast I have ever seen was taken by a photographer from Lemont, Illinois," Randolph continued. "He went within 300 feet of the face of an 800-pound dynamite blast. Then he

waited for his shot until the rock loosened by the blast began to rise above the smoke, so that it appeared in the photograph coming down in showers." The photographer was John F. Geiger, who took about a hundred cyanotypes, a printing process popular among engineers that had the blue tint of blueprints. Geiger's photos, apparently Randolph's favorites, are still in the possession of the district.

THE NEXT BEST SHOW was the parade of astounding machines that helped build the canal. Some—like the locomotives and cable trains that transported material, the steam shovels and pivoting derricks that functioned as workhorses clawing at the channel, and the hydraulic dredges that worked like eggbeaters pulling out muck from the old channel of the Des Plaines River—were, though old hat, the era's biggest and toughest. And some—like the steep-incline conveyors, which were adapted from the nation's coalfields, and the double-tower excavators, which used buckets on long draglines to cut across the entire width of the channel—were being employed in ways never before imagined. The mechanical scene was quite a sight. Repair shops filled with engine lathes, drill presses, planes, and hammers ran almost day and night. "With practically no experience in canal excavation on so great a scale, engineers and contractors have united in developing, for carrying on such work, methods and apparatus which will challenge the competition of the whole world for economy and efficiency," noted *Engineering News*.

The most expensive, elaborate, and extraordinary machine was a Hoover & Mason

double-cantilever conveyor, a 640-foot "monster apparatus" that was specifically designed to remove huge sections of rock and soil. The giant bridge moved slowly down the canal on railroad tracks and had a frame that easily spanned the canal, with two cantilever arms that overhung the spoil piles on either bank. Beneath it was the Bates belt conveyor, an endless rubber belt that moved excavated rock and soil at 120 feet per minute in steel pans filled by laborers and dumped automatically. No matter how many men were hired, they couldn't keep up with the machine.

But the Hoover & Mason conveyor was a spectacular failure. Soon after it was completed in 1894, a support gave way, causing one of its cantilever arms to buckle and crash. Rebuilt, the huge structure was severely damaged in gale winds. The device continued to be used, but without one of its arms. It was never the same.

Smaller versions of the conveyor bridge, which connected the bed of the canal to one of the spoil banks, could be seen all down the canal route. They hauled rock out of the canal using hoppers, also called skips, on tracks.

The most effective machine for moving rock might have been the high-speed Lidgerwood Traveling Cableway. Operating along a fixed cableway between two towers on either side of the canal, the cableway looked a bit like a gondola lift. But instead of transporting passengers, they carried skiffs of rock filled by workers and fastened onto the line. The cableway seemed almost alive, observed the *Tribune*. "The empty car will swoop across the canal like a great bird until it is directly over the desired spot, then it will settle down and alight as gently as if it were not

made of sheet iron and weigh 1,000 pounds."

Running these machines was a workforce that sometimes numbered as many as eighty-seven hundred men. About seven thousand were laborers, who earned around fifteen cents an hour, according to an 1895 report by Joseph Gruenhut, the Sanitary District's labor statistician and a noted Socialist. African Americans and new immigrants from Europe filled the ranks of laborers, doing jobs that required strength, endurance, and skill but offered many breaks. "The men work by the hour and are not rushed or hurried," Gruenhut wrote.

Few men worked full shifts. "They are not obliged to do so, and it is not their habit to work without interruption," Gruenhut continued. "Men may stop work at any time, get their wages and after spending them go to work again on some one of the twenty-nine sections of the Drainage Canal." Many laborers worked only enough hours to pay their living expenses. "This class, who come and go when it suits their convenience, is estimated by thousands, and is nicknamed as 'hobos,'" Gruenhut wrote. "They are mostly native born, of nomadic habits, but the immigrants attempt to get as much work as they can do in this climate, and stick to it except on their church holidays, which are their days of rest and recreation."

Immigrant workers came from Sweden, Austria, Italy, Ireland, Poland, Hungary, Germany, and Britain. Black workers, who were recruited from West Virginia and the South, received the same wage for the same jobs as their foreign counterparts. "This is a great achievement in the necessary amalgamation of the working forces in a mixed population by raising all laborers to the high American

standard of earning a living," Gruenhut wrote. But he noted that blacks, who primarily worked in the rock sections, were forced to live in overcrowded cabins and shanties with little furniture and scant bedding.

The laborers, who could work ten-hour day shifts or eleven-hour night shifts every day but one, were typecast in unexpected ways. The Irish helped run machines. Bohemians and Poles were given the most arduous jobs, such as shoveling and using the pickax. African Americans and Italians were assigned jobs that required a little more skill, such as drilling. And blacks were put in charge of the thousand horses and mules used daily.

Skilled workers—from superintendents, bookkeepers, and clerks to stonemasons, carpenters, and blacksmiths—were primarily native-born whites and earned two to three times more than laborers. "They are few on each section compared with the large number of laborers and remain in their positions as long as they keep sober and behave themselves," Gruenhut wrote.

Most of the unmarried workers lived, for a price, in bunkhouses set up for specific ethnic or racial groups. Married men lived with their families in tents, huts, cabins, and cottages. Before the Illinois State Board of Health passed laws preventing overcrowding, the bunkhouses and surrounding camps bred disease. In 1894, *The Journal of the American Medical Association* sent an investigator to the camps. He found garbage and sewage everywhere. "Health regulations are disregarded entirely and the housing of the men are more like that of neglected swine than of human beings," he reported.

Workers during the early years suffered

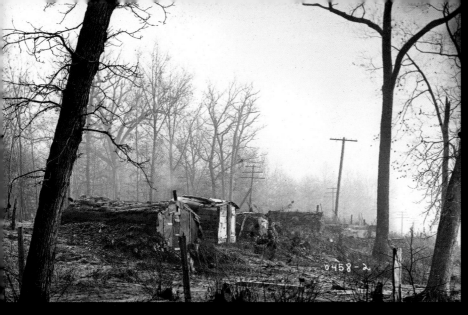

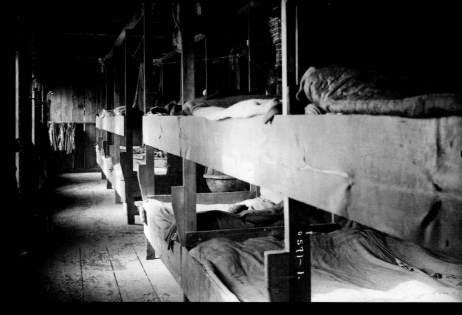

SHANTIES BUILT FOR CANAL WORKERS

BUNKHOUSES WERE OVERCROWDED

CONDITIONS IN

WORKERS FILL A SKIP ON THE LIDGERWOOD TRAVELING CABLEWAY. AFRICAN AMERICANS, RECRUITED FROM WEST VIRGINIA AND THE SOUTH, WORKED ON SIX OF THE TWENTY-NINE SECTIONS OF THE CANAL. "NOT ONLY HAVE FAIR WAGES BEEN SECURED, BUT THE WAGES OF ALL CLASSES HAVE BEEN RAISED TO A COMMON STANDARD," WROTE CHARLES SHATTUCK HILL IN *ENGINEERING NEWS*. "THE ITALIANS AND POLANDERS ARE PAID THE SAME AS THE OTHER MEN, AND THE IMPORTATION OF CHEAP LABOR IS PREVENTED."

from malaria, typhoid fever, pneumonia, peritonitis, and pleurisy. Even though a small fee was deducted from the paycheck of every worker for local hospital care, the sick were frequently put on trains and sent on long and painful rides to Chicago's Cook County Hospital for free care. "We have had all the contractors before us and have asked them to treat their men humanely, but that did no good," said the Sanitary District's chief physician. In 1895, laborers accused contractors of feeding them horse meat.

W. R. Stubbs, the accused cook, denied the rumor. "I use 37,000 pounds of fresh beef every month," he said. "I get it from Swift, and while I do not get the choicest cuts, I get nothing that is not from the choicest cattle." The accusation, which turned out to be false, would not have surprised Nathan S. Davis, a medical professor at Northwestern University, who said he treated several canal workers suffering from scurvy, a disease usually reserved for sailors. "Scurvy is rarely seen today," he wrote in 1912, "for the managers of prisons, poor-houses, and ships are now required by law to furnish those under their care with the needed amount of fresh food." But it was not unknown on the canal.

The Sanitary District did not set the wages of laborers. They were paid by specific contractors, but the district encouraged contractors to keep wages higher than those of the laborers who worked in the nearby stone quarries of Lemont and Joliet because of fears that the canal workers might unionize. In early 1893, laborers refused to work in one section when their hourly pay was cut, but the strike went nowhere. Despite difficult conditions,

there were few attempts to unionize workers, even in that dawning era of American labor power. Canal workers were difficult to organize because many were transients and because they were generally paid prevailing rates. "Trade unions are impractical along thirty miles of a channel in an almost uninhabited stretch of territory along the Illinois and Michigan Canal, and the tracks of two trunk railroads," Gruenhut wrote. "It would not be practicable to picket the route against newcomers, and this explains the constant stream of laborers to fill vacancies in the working force."

~ ~ ~

IN 1893, THE FIRST FULL YEAR OF WORK on the canal, Sanitary District trustees hatched a plan to recruit out-of-work Chicagoans as laborers. The plan seemed to make sense. With unemployment high and men clamoring for work, the district made a special arrangement with contractors to hire thirty-five hundred men, who would apply for jobs at booths set up in downtown Lakefront Park. The first 348 boarded trains at six o'clock on a September morning and headed southwest with high hopes. They arrived at Willow Springs an hour later and were put to work for a while before being told to march seven miles west, where they endured a grueling ordeal of hard canal work.

By the 7:00 p.m. quitting time, only five were still on the job.

A few days later, the *Tribune* interviewed some of the workers. Two sturdy young men who had previously worked as iron molders said they couldn't keep up with the experienced canal workers. A sullen foreman called them names and treated them like convicts, they said,

even refusing their requests for water. Insane from thirst, they quit: "Our condition was intolerable, and there were only two things for us to do, get water or fall in our tracks." The two contended that they didn't have a chance. "As soon as a man would come on the dump he would be asked the question, 'Are you a citizen.' If the reply was in the affirmative his troubles commenced at once. The bosses simply did not want us out there. They own the groggeries and the boarding-houses which make up the camp, and between the two kinds of businesses they manage to get hold of about every dollar that the workmen earn."

That contention was probably correct. As hard as the men worked, few managed any savings. Beer wagons followed regular routes, especially in the Austrian settlements near Willow Springs and Lockport. Italians, Poles, and Austrians bought beer by the keg or half barrel. But most of the workers preferred to drink in bars. Seventeen saloons opened in and around Summit, twelve around Willow Springs. Ground zero was Lemont, where half the aldermen were saloonkeepers and about a hundred dancehalls, gambling dens, saloons, and bawdy houses ran day and night. The first Saturday of each month was payday. Sometimes contractors paid workers right in local taverns, where, after their bar tabs were settled and money was deducted for room and board and the hospital fee, many left with nothing.

"Hundreds of workmen in search of amusement gathered nightly, a reckless and vicious crowd, ready at any moment to jeopardize their lives or commit any form of excess," reported the *Tribune*. "They were the prey of the saloonkeeper and the gambling 'shark' alike, and in turn they robbed each other if a chance was offered. They fought among themselves, sometimes in the heat of passion and sometimes for the mere sake of fighting. They drank deeply of the most villainous stuff ever concocted, danced until they were tired out, and then sought sleep in their bunks."

~ ~ ~

LABORERS WORKING AT NEARBY QUARRIES went on strike on June 1, 1893, after their wages were cut to match those paid to Sanitary District workers. The following day, striking quarrymen filled the saloons of Lemont and convinced many canal workers to join them. A mob of about a thousand marched through the streets to the camps in search of more men. Strikers gathered workers along the way in their quest to halt all canal work, beating up two foremen who tried to stop them. But the contractors soon took action. "It was then that a brother of the two members of the firm who had been roughly handled by the strikers sought to execute a plan of revenge which would have been terrible in its results if it had been carried out," the *Tribune* reported.

The man laid dynamite across the towpath, the channel right-of-way, and the nearby railroad tracks the moment the strikers passed the contractor's office. The trap was designed to kill hundreds of men, but the man's boss convinced him to abandon the plot. "His argument that the firm would be ruined proved effective at the last moment, and the contractors seized their Winchester rifles and awaited an attack on the offices," the *Tribune* said. "The strikers, however, did not molest them further."

The strikers kept work to a minimum. The next week, they gathered on the Illinois and Michigan Canal and again marched to the camps. After ignoring an order to stop, they were fired at by Will County sheriff's police and private guards armed with rifles supplied by contractors. The mob turned and started to flee, but police and guards kept firing, killing two and injuring more than a dozen strikers.

The next day, Illinois governor John Peter Altgeld sent eight hundred members of the state's militia to the scene. He arrived, too, to investigate. Altgeld's report contradicted newspaper accounts, which blamed the strikers. "In short, the only men who seem to have violated the law yesterday, and that in cold blood, were the men who had been armed by this contractor and who did the shooting," Altgeld said. Some contractors claimed the strikers fired first, but no bystanders ever confirmed that. Altgeld later told state legislators: "There can be no question about the fact that the pursuing of the men who were fleeing for their lives, and shooting them down at various points while they were running away, and finally killing a man at the distance of a mile, was a wanton killing, and therefore murder under our laws."

The labor strife subsided after two Illinois regiments entered Lemont. Altgeld would essentially end his political career two weeks later when he pardoned three anarchists accused of murdering a Chicago police officer in the Haymarket riot.

~ ~ ~

IT IS HARD TO ESTIMATE how many died during the construction of the canal. The *Tribune* reported that 279 men met violent deaths: some 103 were killed in work accidents, 56 were killed

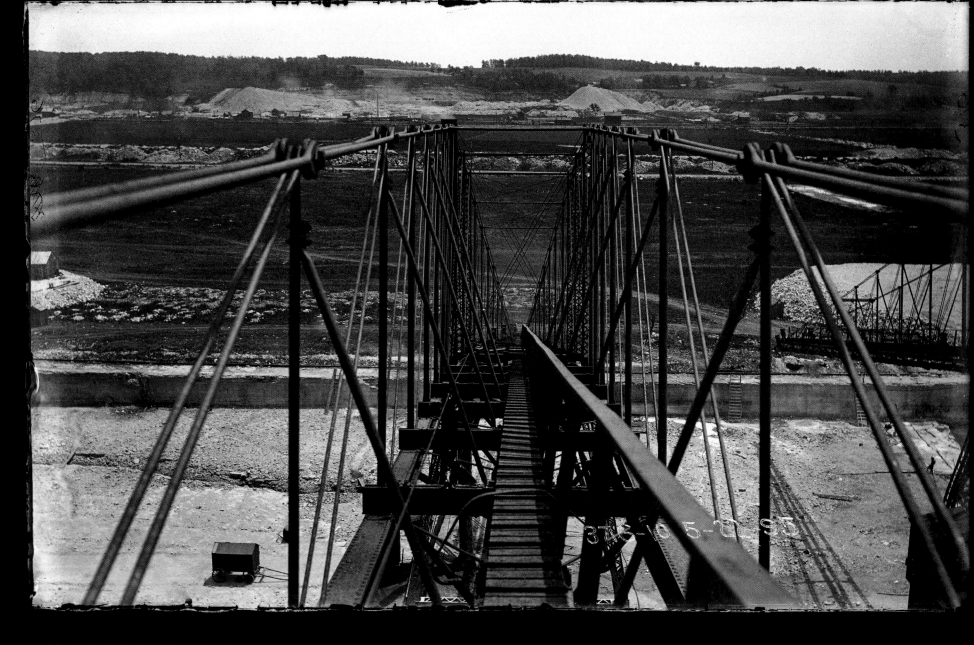

ATOP THE BROWN HOISTING & CONVEYING MACHINE, A WORKHORSE IN THE ROCK SECTION. BUILT TO TRANSPORT COAL AND ORE, THE MACHINE WAS MODIFIED AT THE CANAL TO CARRY BROKEN ROCK 355 FEET TO SPOIL BANKS.

by railroads, 45 drowned, 42 were murdered, and 33 were found dead of unexplained injuries. "Accidents were of daily occurrence," the newspaper said in 1900. "Familiarity with the use of explosives made the men careless and they suffered in consequence while the blasting operations went on. Machinery became out of order and added to the fatalities. Drunken workmen strayed in their footsteps and became the victims of passing trains on the Chicago and Alton and the Santa Fe railroads, while the water in the Illinois and Michigan Canal claimed its share of the dead."

The deaths and accidents, many reported in detail by the newspapers, were spectacular. Nine men were killed and six seriously injured in 1893 when an iron crane toppled by gale winds fell on a hut where men sought shelter. "The majority of the dead are colored men, who were best known by numbers, so that it is well nigh impossible to obtain a full list of the dead," said the *Tribune*. The following year, two men were killed and six injured after an Italian laborer, Christopher Tesavi, accidentally struck with his pickax a charge of dynamite that had not fired. "Tesavi was so frightfully mangled and so covered with the dirt and dust that he was scarcely recognizable as a human being," the paper said.

In 1894, John Nieponski and an unknown man were killed and two others injured after they fell from a hoisting bucket. The following year, twenty-five boxes of dynamite exploded in a powder house. Instructed to retrieve supplies, two men had used a stick and paper as a torch to see what they were doing inside the powder house. When they dropped the torch, they tried to put out the flame, then ran. "They remembered how a mob wanted to lynch the man responsible for the fatal explosion of Monday—in fact, they had been members of it—and so they proceeded to get as far away as possible," the *Tribune* reported.

~ ~ ~

BY LATE 1896, most of the $33-million canal had been built. But it would not be done until bridges and key engineering details were finished and inspectors and the governor gave approval. "As it stands to-day the canal is a dreary waste—a dull succession of completed but not connected sections," wrote Theodore Dreiser in 1899, just one year before both he and the canal would make grand debuts. "All that remains now is to dig out the small dividing bars of land and the channel will stretch uninterrupted for twenty-seven miles."

St. Louis also stood in the way of the canal. The Missouri metropolis, forty miles south of the Illinois River's mouth, started fighting the drainage ditch in the mid-1890s when Representative Richard Bartholdt introduced bills in Congress directed against the pollution of interstate rivers. The St. Louis Republican argued that sewage running down the Illinois River into the Mississippi would poison river towns all the way to New Orleans. St. Louis was particularly vulnerable, he said, because germs could live for four weeks in water. St. Louis's top experts joined Bartholdt in attempting to debunk Chicago's self-purification theories. Dilution, storage, agitation, and filtration would not make Chicago's sewage pristine, Max Starkloff said: "I consider it my solemn duty as health commissioner of St. Louis to point to the flimsy and unstable scientific foundation upon which the canal authorities are proceeding."

In 1899, the St. Louis City Council authorized the city attorney to file a lawsuit to prevent the opening of the Drainage Canal. Missouri's attorney general, Edward Crow, started preparing cases in the federal courts. Rumors abounded through the last months of the year that Missouri was on the verge of filing injunctions to stop the canal, which pushed the Sanitary District to complete the job fast.

Finally, on New Year's Day 1900, the Sanitary District trustees determined that the canal was ready to open. At ten o'clock that night, a dredge started scooping out a small ridge of earth that separated the Chicago River and the Drainage Canal at a side canal just east of Kedzie Avenue near Thirty-First Street. There was no ceremony or official announcement; the nine trustees and the chief engineer, Isham Randolph, met at the site in secret so they could start the flow of water as soon as possible. Wives and friends, a few newspaper reporters, a photographer, and Ossian Guthrie, who wanted to see his idea spring to life, joined them. The *Chicago Evening Post* reported that Guthrie braved the fierce winds and "ventured dangerously near the dredge in order to hasten the work of clearing away the obstruction."

It was cold; there was no pomp and there were no speeches. The trustees and the few in attendance huddled around bonfires. Trustee Bernard A. Eckhart arrived with a set of shovels. Not nickel-plated shovels, but common store-bought ones. The trustees then started digging, but it soon became obvious that they weren't making much progress in the frozen earth, so the dredge was called in. The heavy machine couldn't reach the clay and ice that prevented

the connection, so dynamite was brought in. "With the aid of a few charges of dynamite in the frozen earth, the first one set off by President Boldenweck with mighty oaths, a breach was at last made and the water started to flow into our man-made river," Randolph recalled years later in his *Gleanings from a Harvest of Memories*.

It wasn't quite that simple. William Boldenweck, who replaced Frank Wenter as president, did set off the dynamite and the small crowd headed for cover, but the blast was "a miserable little report entirely unworthy of the event," the *Chicago Evening Post* said. It moved the dirt and clay a bit, but when the crowd rushed back to the cut, it looked just as it had before.

Once more the dredge was called in, but again to little avail. "At this point there was much profanity from several of the trustees, all of which made Contractor (Tom) Gahan look hurt and uncomfortable as he soiled his red gloves trying to help his men," the *Evening Post* reported. The dredge finally worked its way into position to pick up a monster scoop. After two hours of work, the crowd shouted: "It is open! It is open." The water trickled down twenty-four feet from the South Branch to the new canal. "It is the Niagara of Chicago," Eckhart declared. The trustees gathered along the new Niagara for a formal picture. Randolph removed his bowler and smiled. Boldenweck, whose parents had died during a cholera epidemic decades before, declared: "Water is now in the canal, and I do not see how anybody can stop us."

Proclaimed a *St. Louis Star* headline: "Windy City Sewage Is Now Headed This Way."

On January 3, the Chicago papers reported that the Chicago River looked cleaner. People noticed a slight current. Tugboat operators said they could see clear ice on the river for the first time in decades. That same day in Washington, Representative Bartholdt tried to convince the War Department and the Justice Department to stop the flow. The U.S. attorney general, John W. Griggs, listened patiently and then asked Bartholdt what he wanted him to do.

"I want your opinion in the matter," retorted the congressman.

"Only the president of the United States is entitled to my opinion," was the reply.

On January 4, fishermen showed up on the Wells Street Bridge. "Clear water in the Chicago River—water that was actually blue in color and had blocks of ice of a transparent green hue floating in it—caused people who crossed bridges over the Chicago River yesterday to stop and stare in amazement," the *Chicago Record* reported. Across Lake Michigan in Benton Harbor, residents claimed that the lake level was down a bit. On January 5, the first water in the ditch made it to the western edge of the canal, the controlling works at Lockport, where a dam held it until the canal was filled. On January 8, a crowd of four thousand drove to the controlling works. The Sanitary District flexed its muscle by "testing" the machinery that would soon be used to connect the rivers. Back in Chicago, people packed streetcars to see the Chicago River flow into the canal. They were certain that the river had a greener hue.

On January 16, St. Louis's fight in Congress against the canal came to an abrupt end when Richard Bartholdt asked Illinois representative William Lorimer privately if the rumors were true that his state's congressional delegation would work to prevent St. Louis from getting federal money for the 1904 world's fair if Missouri continued to oppose the canal in the House.

Lorimer said that indeed it was true. Bartholdt dropped his opposition and St. Louis got its fair.

But that did not stop the legal battle, which went on six years in the Supreme Court and has continued in courts in similar form for more than a century. Still worried that Missouri would slap an injunction on the canal, trustees rushed to Lockport the moment canal waters filled the channel and pushed against the Bear Trap Dam, which regulated the flow of water into the Des Plaines River.

Once again, there was no announcement or special ceremony. On January 17, Isham Randolph gathered the trustees secretly at the Technical Club on Clark Street, opposite the Federal Building, and arranged for a Santa Fe train to meet them at the Eighteenth Street Viaduct. The *Chronicle*, *Tribune*, *Inter-Ocean*, and *Record* each sent a reporter, but they were not given access to the telegraph until 4:00 a.m., after the deadlines for the morning papers. Once in Lockport, the trustees contacted Governor John R. Tanner, who signed a formal permit that could start the flow.

When President Boldenweck said, "Let her go," the trustees hastened to the wheels to lower Bear Trap Dam beneath the water level. Wrote Randolph: "The mighty steel barrier sank slowly and majestically beneath the flood which leaped over its crest and, rebounding from the temporary footway at the bottom, surged up in a mighty, foaming billow whose force soon tore away the temporary woodwork and, amid congratulations and cheers, the mighty purpose of the mighty work was accomplished."

They estimated it would take a week for the water to reach the Mississippi River. Its effect would last forever. ✒

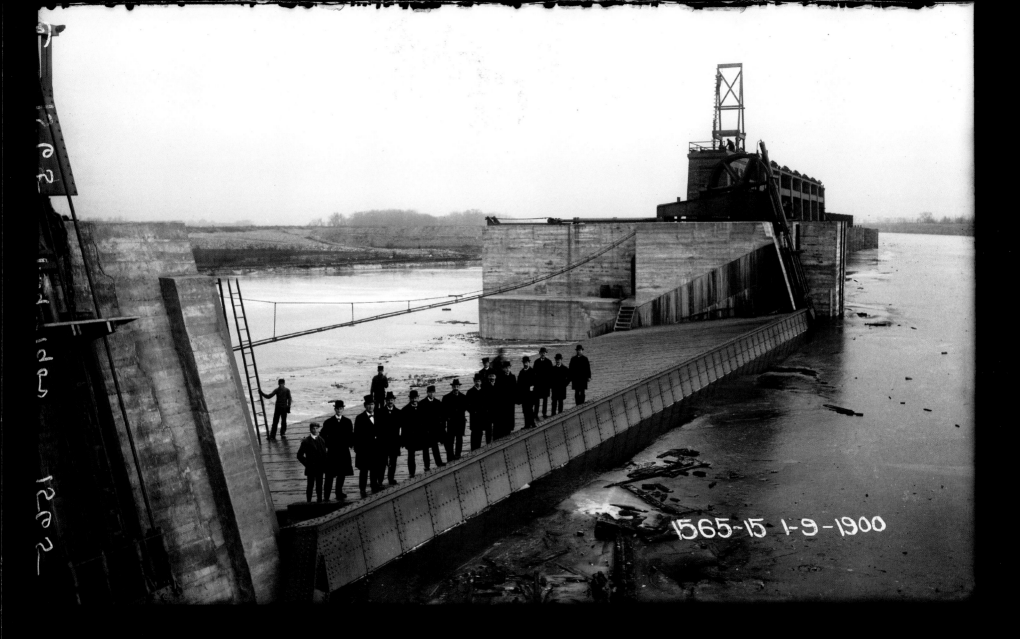

1565-15 1-9-1900

SANITARY DISTRICT TRUSTEES ATOP BEAR TAP DAM IN LOCKPORT, SEVEN DAYS AFTER WATER FROM THE CHICAGO RIVER COURSED INTO THE DRAINAGE CANAL. THE LOCK CONTROLLED THE FLOW OF THE CANAL AND REGULATED THE AMOUNT OF WATER FLOWING INTO THE DES PLAINES, ILLINOIS AND MISSISSIPPI RIVERS. THE TRUSTEES RETURNED TO THE DAM ON JANUARY 17, 1900, TO LOWER THE DAM AND START THE CURRENT FLOWING ON ITS WAY TO THE GULF OF MEXICO.

PART II

BOUND FOR CHICAGO

A 327-MILE PHOTOGRAPHIC JOURNEY FROM THE MISSISSIPPI RIVER
TO LAKE MICHIGAN SHOWS A TRANSFORMED LANDSCAPE—
CHICAGO'S GRAND EXPERIMENT BROUGHT UNFORESEEN
CONSEQUENCES THAT ARE STILL FELT TODAY

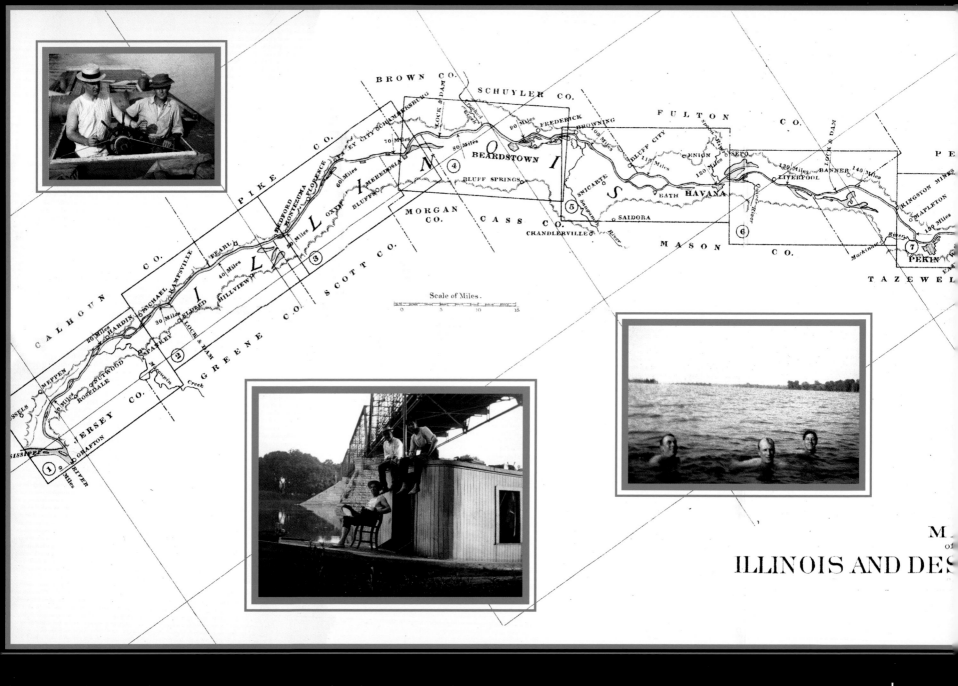

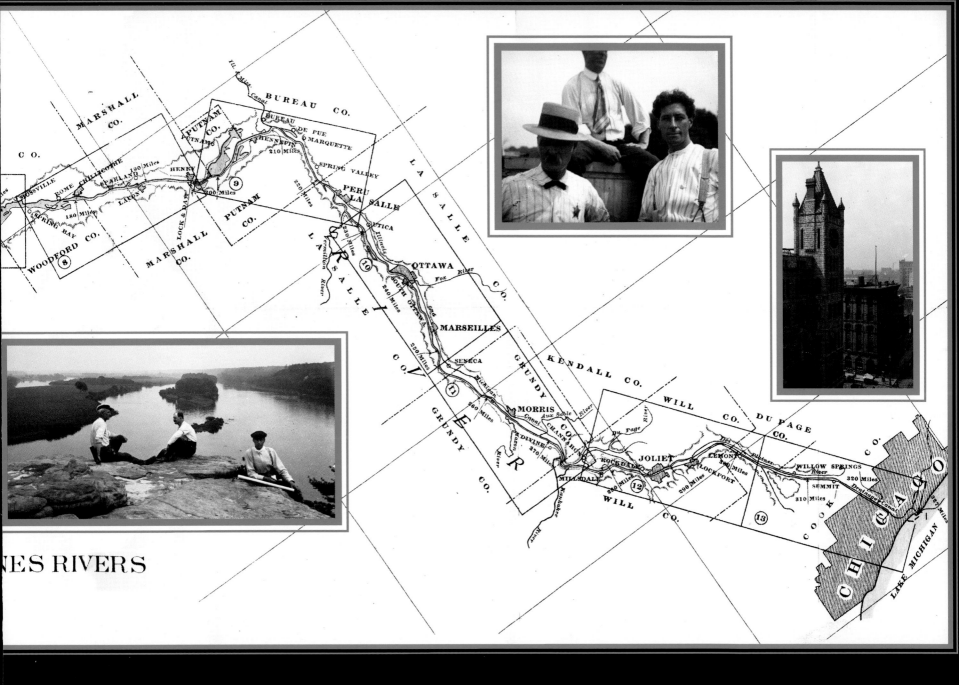

PHOTOGRAPHS ALONG THE CALUMET-SAG CHANNEL, THE NORTH BRANCH OF THE CHICAGO RIVER, AND TRIBUTARIES OF THE ILLINOIS RIVER HAVE NO MILEAGE NUMBERS BECAUSE THEY ARE NOT ON THE DIRECT ROUTE. CAPTIONS INCLUDE DATES IF THEY ARE NOT ETCHED ON THE NEGATIVE.

697-8-26-1908

THE ILLINOIS RIVER NEAR HARDIN

The reversal of the Chicago River in 1900 changed Chicago and the Illinois Valley forever. During the nineteenth century, residents of St. Louis and towns along the Illinois River expressed concerns about the smell and disease that the polluted water heading down the Chicago Drainage Canal (known after 1900 as the Chicago Sanitary and Ship Canal) might bring. The new canal brought much more than that.

The rush of water from Lake Michigan and the Chicago River almost doubled the size of the Illinois River. It widened, swamping adjacent backwater streams and lakes, and submerged islands along its route. The larger and faster river uprooted bottomland trees and killed vegetation as it pushed against and eroded the shores. From 1903 to 1921, half the river's wildlife habitat was eliminated. Some was erased by the rising river; some when farmers built levees to protect their property and reclaim fertile low-lying land. By 1929, about forty drainage and levee districts were created, enclosing a total of two hundred thousand acres of the Illinois River floodplain.

The new farms, contoured and tiled to resist floods, and growing cities along the river added to the transformation of the landscape by sending sediment into nearby creeks and streams. Low dams along the river increased the water level and trapped huge amounts of debris. Half of the surrounding lakes, which had swelled during the first years after the canal was built, disappeared due to sediment. When the Drainage Canal was opened in 1900, the lakes along the Illinois River were eight to twenty feet deep. Their average depth today: eighteen inches.

At one time, the Illinois Valley was the nation's largest inland fishery, supplying a tenth of the freshwater fish caught in the United States. The Sanitary District's Main Channel changed all that. At first, the river's abundant fish thrived in their new, larger setting. But as pollution increased, the oxygen level in the water dropped, killing them off or forcing them into cleaner tributaries. By 1917, not many were found north of Utica, forty-three miles downstream from the start of the Illinois River. By 1923, few were found north of Chillicothe, another fifty miles downstream. One of the few species that survived, the common carp, developed a malformed head in some sections of the river.

In 1900, photographers hired by the Sanitary District of Chicago began documenting the new Illinois River. Over the next three decades, they carefully filmed the 327-mile stretch along what became known as the Illinois Waterway. They were supposed to show changes resulting from the increased water flow that would have legal ramifications. Unintentionally, they compiled an unsurpassed biological and geological record of a waterway under assault.

▲ Mile 0: Small islands mark where the Illinois River empties into the Mississippi River, forty miles upstream from St. Louis. This view, taken in 1920, looks southwest from Grafton, Illinois, into the Mississippi. The year after the Drainage Canal opened, the Illinois State Board of Health sent representatives to Grafton. They determined that no Chicago sewage was still in the Illinois River by the time it reached the river's mouth. This report has been lauded and disputed ever since.

▶ The Julia Belle Swain, which ran as an excursion boat on the Illinois River during the early twentieth century. The first steamboats made their way up the Illinois River in 1828. Twenty-five years later, eighteen hundred were traveling to Peoria and points east. Steamers changed the geography of the river. Their boilers were loaded with wood harvested from trees near the river, and their engines filled the air with soot. But their traffic also helped settle towns north of Peoria and south of LaSalle in the mid-1800s.

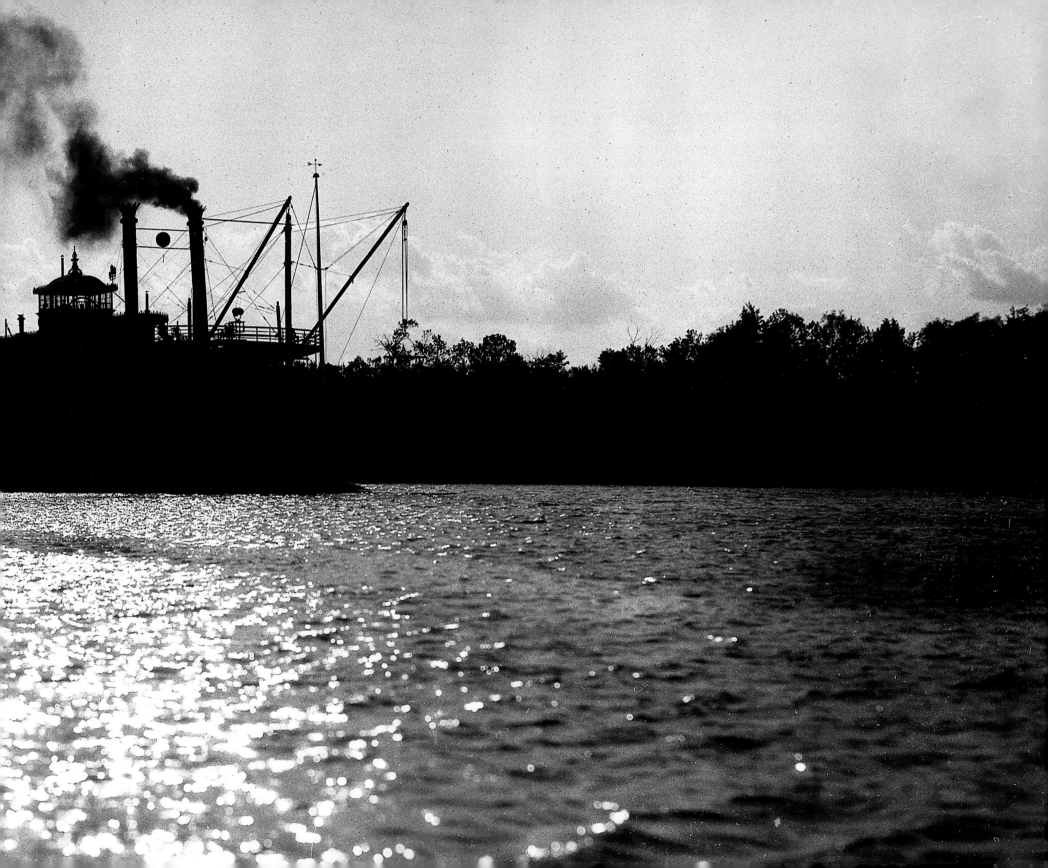

694-8-26-1908

693-8-26-1908

Mile 22: Looking south over the town of Hardin, in Calhoun County, on the western edge of the Illinois River. The county, Illinois's most isolated, is wedged between the Mississippi and Illinois Rivers. It has changed remarkably little.

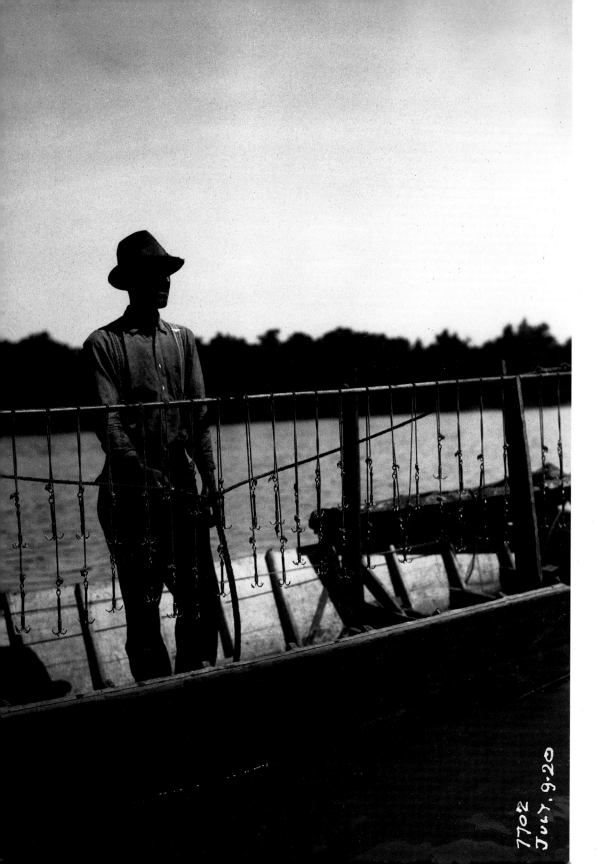

◄ Mile 65: A mussel harvester near Naples. The Illinois River once supported more freshwater mussels per mile than any other river on the continent. Scooped up from the river bottom, the mussels were used to make pearl buttons. A clammer would drop about three hundred of these crowfoot hooks from his boat to snare the immobile freshwater clams, which could live to be a hundred years old. The industry defined river life during the early twentieth century; at its peak, around 1909, twenty-seven hundred flat-bottomed fishing boats worked the stretch of the Illinois River from Grafton to Peru harvesting mussels.

► Mile 65: Steam vats were used to cook mussels out of their shells, which were cooled, washed, sorted, and stacked. The lustrous shells were then taken to local factories or shipped by barges to larger factories, where they were cut and shaped into buttons to be sold in stores all over the world. Increased water from the Main Channel was a boon to the industry—for a while. By 1930, the river was almost fished out, and mussel buttons were replaced by plastic ones.

Mile 66: The Varner Bridge over McKee Creek, a meandering, sandy-bottomed tributary that empties into the Illinois River from the west, opposite Naples. The bridge, photographed in 1913, was built out of native lumber in 1882. It was named after one of the workmen, Isaiah Varner, who lived along the creek. In 1951, uprooted trees and brush from the flooded creek slammed against the side of the bridge. Neighbors held an all-night vigil to see if the bridge would survive, but it didn't. The Varner was replaced by an iron bridge, which was washed out by a flood eighteen years later. Fishermen prefer the catfish from McKee Creek to those from the muddy Illinois because they are cleaner and their bellies are white instead of greenish brown. The creek was where Potawatomi Indians from Indiana camped after crossing the Illinois River by ferry during their forced removal to Kansas in 1838 along the Trail of Death. Three years earlier, their counterparts in Illinois were forced west of the Mississippi River, which opened the state to development.

The hero of this photography project is E. H. Heilbron, who was placed in charge of documenting the Illinois Valley soon after the Main Channel opened. Heilbron was the brains behind the project's last three decades. He told photographers exactly what to shoot and even posed for many of the pictures.

Emile Henry Heilbron, who went by E. H. most of his professional life, was born in Rochester, New York, in 1872 and moved to Chicago by his late teens. He was hired by the Sanitary District in 1892 as a flagman and rose through the ranks of its engineering department despite having no advanced degree. His son Edward speculates that his father's success was the result of hard work, loyalty and an uncanny ability to add numbers quickly: "My father could watch a train pass by and add the serial numbers of each of the boxcars in his head." On paper, he could run his fingers down a column of four- or five-digit numbers and come up with an immediate tally.

For close to thirty years, Heilbron made surveys of the valley and was responsible for the legal defense of the district after downstate farmers filed lawsuits alleging the swollen Illinois River had damaged their property after the Sanitary and Ship Canal opened. To prepare that defense, he created a photo record of the Illinois Valley. Almost all the leather-bound volumes produced by the district after 1900 clearly state that they were compiled under the direction of Heilbron.

At six feet two, Heilbron parted his hair down the middle, smoked cigars, and could handle a boat as well as anybody. His first love at work was the Illinois River. He grew to know and appreciate it like few others. He built a house at the foot of Beech Street in Chillicothe, where he set up the district's Illinois Valley offices on property that he said offered the best views of the river.

In 1929, the CHICAGO TRIBUNE ran a photo of Heilbron sounding the Illinois River with a nineteen-foot pole from a tiny boat in the river at Dresden Heights. Heilbron told a reporter that the work convinced him and members of his group that not much dredging would be needed to make the river fully navigable once a series of dams were built. "The wild scenic beauty of the countryside through which the expedition passed may well prove an attraction to excursion steamers," he predicted.

Heilbron was killed in 1945 when a train struck his car in Chillicothe. He was still working for the district. After his death, the Sanitary District trustees passed a resolution noting his "unimpeachable character, kindly nature, and great ability." No mention was made of the photographic legacy that he left behind.

8·6·05

E. H. HEILBRON

1554- 7- 25- 1912

◄ Mile 80: A grove of maple trees just east of the Illinois River by Swan Lake. The South Beardstown Drainage and Levee District apparently later drained the large lake. At least thirty-one backwater lakes and marshes that served as breeding grounds for fish were lost when farmers created drainage districts on both sides of the Illinois River, partially in response to the increased flow.

► Mile 93: A cottonwood tree felled on the east side of the river about five miles north of Beardstown and the Sangamon River. Lumber from the bottomlands was a productive commodity until farmers along the lower Illinois River found they could make more money reclaiming their land by constructing levees. "Every year adds to the area of tillable land on our river bottoms, and the time is not very distant when their entire surface will be susceptible of cultivation," wrote the state geologist, Amos Henry Worthen, in 1870.

1911-7-23-1913

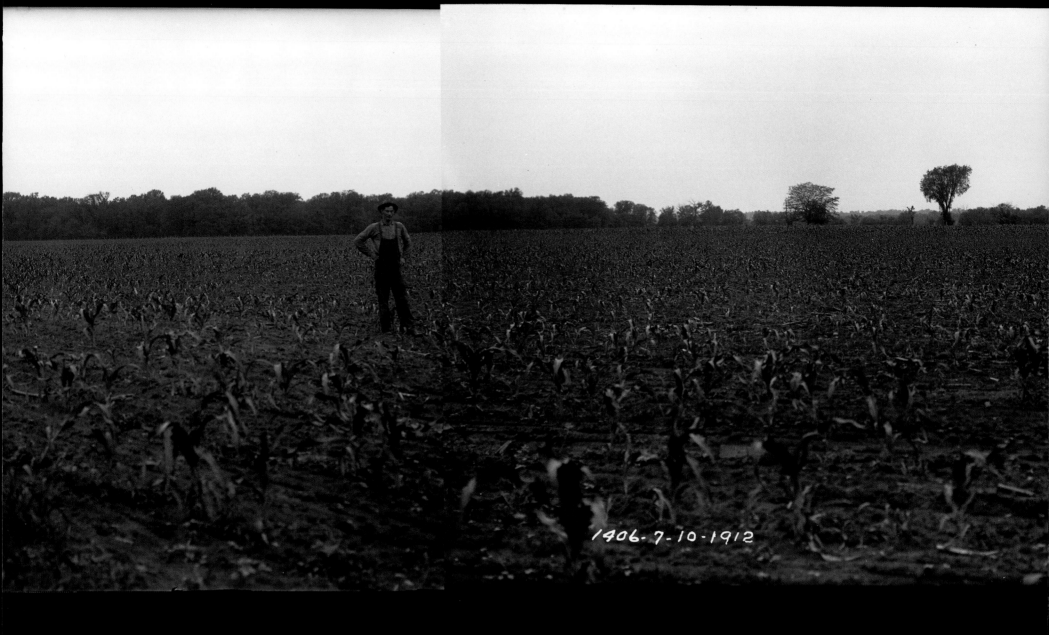

1406. 7-10-1912

Mile 110: A farmer on Grand Island, the largest island on the Illinois River. At the time, corn was planted in rows three feet apart to make room for a horse-drawn cultivator that would plow and weed. Now—with the advent of fertilzers and pesticides—corn is planted six inches apart. "That's not fooling mother nature; that's improving mother nature," said farmer Leon Stambaugh, who once worked with the old cultivators.

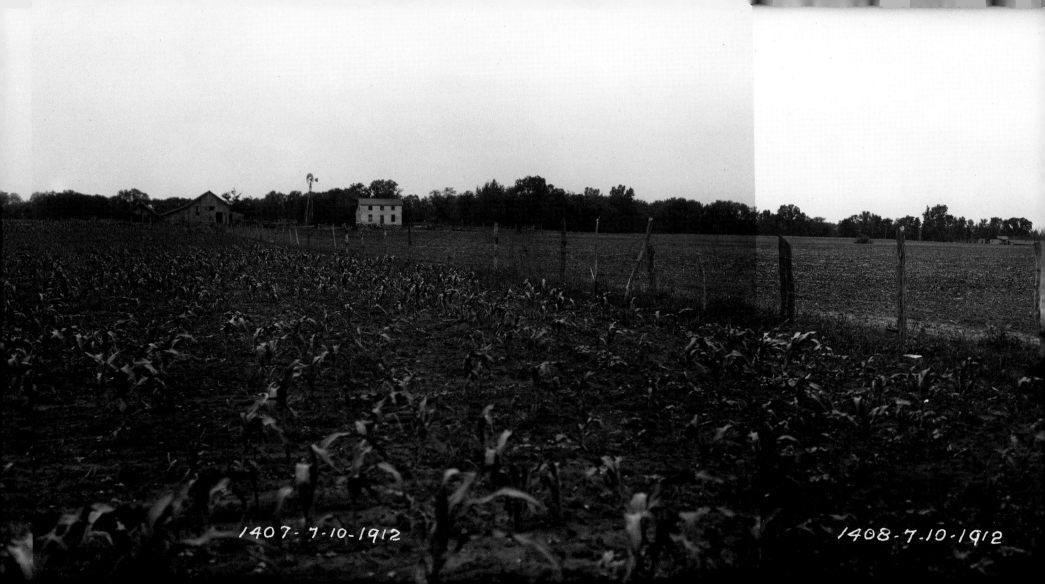

1407 - 7-10-1912

1408 - 7-10-1912

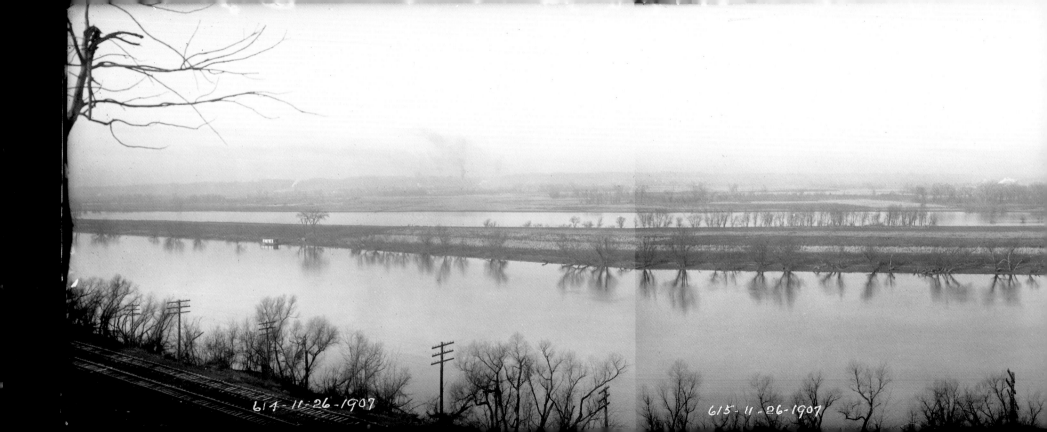

614 - 11 - 26 - 1907

615 - 11 - 26 - 1907

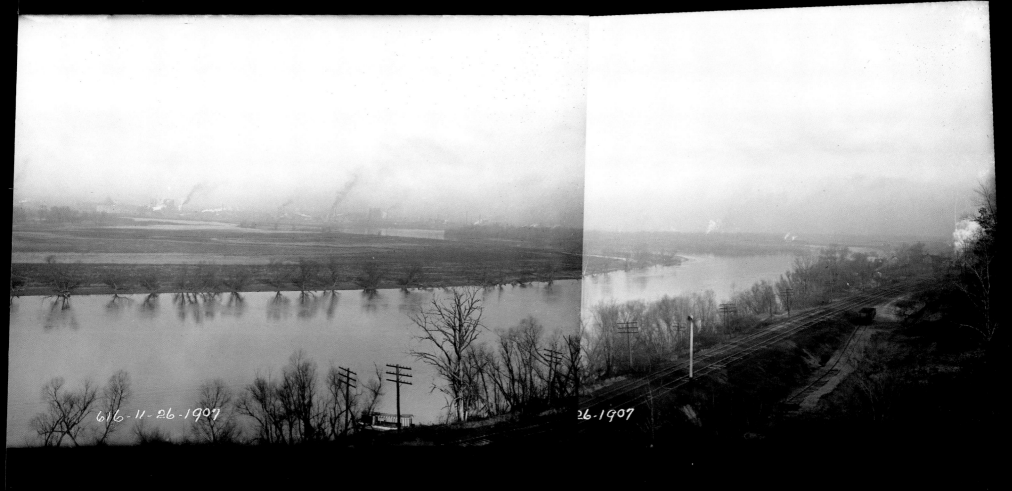

616-11-26-1907

26-1907

Mile 159: Peoria from a bluff overlooking the Peoria and Pekin Union Railway tracks near present-day Fort Crevecoeur Park. Smokestacks used to be a badge of honor for cities, a sign of economic prosperity. In 1680, French explorer René-Robert Cavelier, Sieur de La Salle, built Fort Crevecoeur in the immediate area to serve as a supply center. Two years later, he sailed to the mouth of the Mississippi River and claimed the territory for France. The actual location of the fort has never been determined.

131.9.29.05

122.9.29.05

124.9.29.05

132.9.29.05

121.9.29.05

123.9.29.05

HEILBRON POSE
FOR SCALE, 19C

In order to win support among downstate legislators, a provision was included in the 1889 bill that created the Sanitary District of Chicago specifying that the district would pay any damages caused by the additional water sent down the Main Channel to the Illinois Valley.

Soon after the canal opened, the district was overwhelmed with lawsuits. Landowners who believed their farms suffered permanent damage from the new flow had exactly five years to file their cases. By January 17, 1905, the fifth anniversary of the opening of Lockport's Bear Trap Dam, 272 cases had been filed in local courts by farmers from thirteen downstate counties seeking a total of $5 million in damages. During the next fourteen years, another 143 farmers filed temporary-damage claims after floodwater swamped their property.

The Sanitary District panicked, fearing that, if successful, the lawsuits would bankrupt it. After a Woodford County farmer, B. F. Zinser, was awarded $15,000 in damages, district attorneys knew they must take a strident position in court to fight every claim. The PEORIA TRANSCRIPT reported in 1906 that the district was gathering information and data to "sandbag all land owners who start damage suits." Photography became central to the district's defense. Pictures showing tall corn and dry conditions could be used to counter claims of poor harvests or permanent damage. Farmers, said the Peoria newspaper, "who have counted upon getting large damages . . . will have to be more careful with their facts than they evidently were in recent suits heard in the Peoria circuit court."

E. H. Heilbron took charge, sending photographers to the property of every landowner who filed suit and to document the floods of 1902, 1904, 1909, 1916, 1922, and 1926. The defense proved effective. A Peoria farmer who sued the district for $55,000 walked out of a Peoria courthouse after a thirty-eight-day trial with $750.

The district used every means possible to win. It hired dozens of surveyors and engineers to document damaged property, delayed court cases for years, appealed many losses to the Illinois Supreme Court and even battled over attorney fees. By 1919, fourteen years after the 272 permanent-damage claims were filed, the district had resolved only 123 of them, paying out a grand total of just $370,000 of the $2.4 million sought. A special court, the Illinois Valley Claims Commission, was set up in 1925 to close the cases, but many were still on the books when Heilbron died two decades later.

The result of the fighting between the district and downstaters was palpable. In 1924, Guy L. Shaw, a former congressman from Beardstown, told a House committee: "They had overflowed the land, they had killed thousands of acres of timber, and they had ruined many acres of land from an agricultural standpoint. They have almost destroyed some of the villages and cities along the river, and the supply of fish and animal life in the river has been destroyed; the conditions have become intolerable."

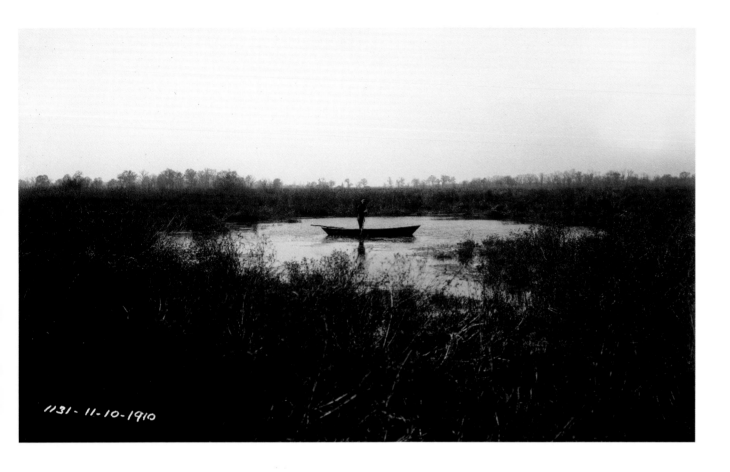

1131-11-10-1910

▲ Mile 178: Bull Spring on the Hunter property in Woodford County, about two miles east of the town of Rome and Peoria Lake. The Sanitary District fought downstate lawsuits with determination. The landowner M. Hunter sued the district for $40,000 in flood damages in 1905. A jury handed down a $9,000 verdict five years later, which was reduced to $6,000 in 1912.

▶ Mile 180: A farmer on the Jones property, about two miles east of Chillicothe and Douglass Lake, in 1913. Douglas Jones sued the Sanitary District for $15,000 in damages in 1905. His wife, Jane, won a $5,480 verdict eight years later, which was affirmed by the Illinois Supreme Court. Settlers were attracted to Woodford County by its thick forests on adjacent hills, its water springs bursting in "crystal floods," and by the Illinois River with its "broadening sweep and surge sublime," according to an 1878 county history.

583-11-22-1907

584-11-22-190

Mile 182: Cornstalks dot farm fields in Marshall County at harvest time. This vista, looking south, is about a mile east of the river. In 1906, a Peoria hunter wrote about the changes he saw after the Sanitary and Ship Canal opened. "All of the favorite shooting grounds within fifty or sixty miles of [Peoria] in either direction afforded cover as secure as shooting from behind a barn," he wrote. "Now these same marshes are open lakes of water, without a stalk of wild rice or a bunch of smart weed or buck brush to afford the hunter a natural blind."

585-11-22-1907

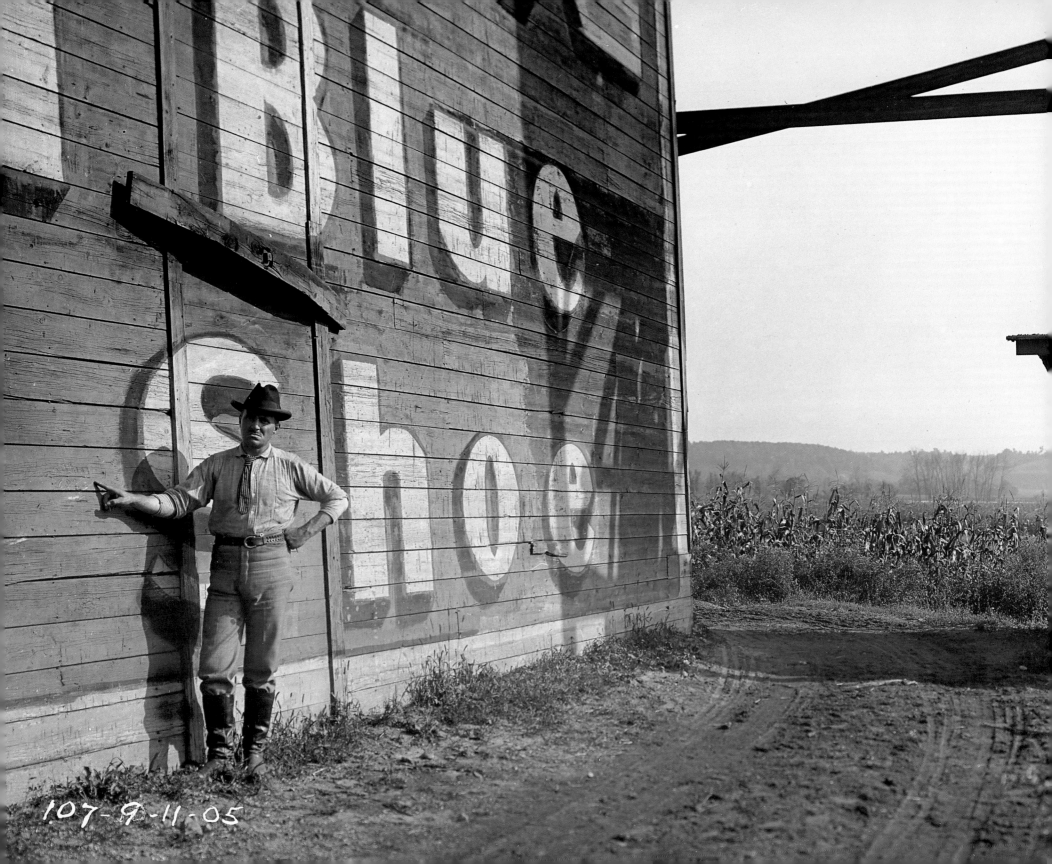

107-9-11-05

Mile 218: High-water marks at the Guenther Ice House near Spring Valley in Bureau County, just east of the Great Bend of the Illinois River, which separates the upper and lower sections. The flood of 1904 raised the river to its highest level in sixty years, overflowing neighboring farms. An estimated 280,000 acres of farmland and 50,000 acres of bottomland lakes were submerged by the rising river. Three members of the Guenther family sued the Sanitary District for the overflows but, after years of litigation, did not win any money.

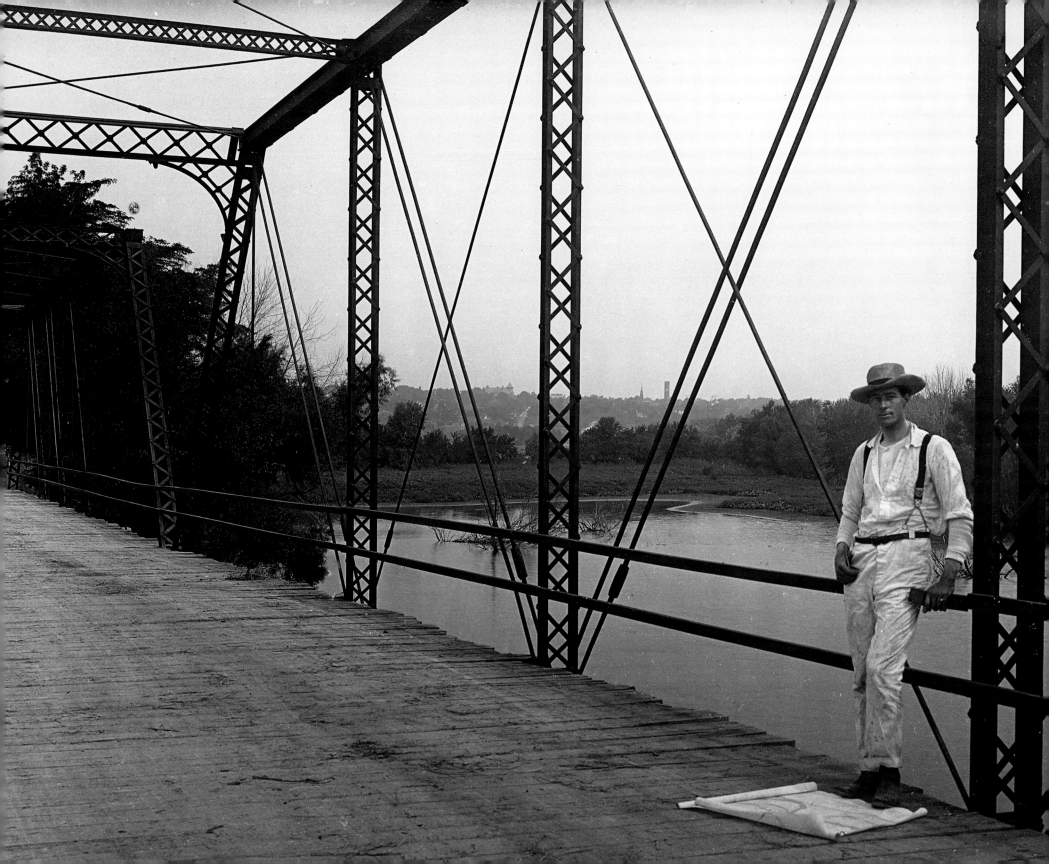

GG. 9-11-05

◂ Mile 222: E. H. Heilbron, with surveys, on the Peru Roadway Bridge in 1905, half a mile south of Peru. The bridge, which was replaced in 1917, spanned the Peru Slough, an Illinois River backwater. Before refrigeration, ice was harvested in the slough. Water from Lake Michigan raised the level of backwaters and wetlands, which benefited fish at first. But the high water submerged and killed important vegetation that they depended on for food and habitat.

▴ Mile 225: Heilbron poses with boaters on the Illinois River as they approach the Vermilion River.

201- B.4.1906

▲ Mile 226: The mouth of the Vermilion River. The seventy-five-mile tributary, one of the state's best canoeing and kayaking rivers, empties into the Illinois River northwest of Oglesby in LaSalle County. Sanitary District photographers documented nearby streams because they affected the river's flow.

▶ Mile 226: Beautiful Bailey Falls, the miniature Niagara Falls of Central Illinois, was shut down by the Marquette Cement Company. The company rerouted Bailey Creek, which fed the thirty-foot falls, when it was quarrying limestone in the 1950s. The creek is a tributary of the Vermilion River. Evelyn Moyle, of Oglesby, remembers the falls as the place to go for picnicking and camping during the Depression. If the water was low, people would drive their Model Ts into the stream above the falls to wash their cars. "It was a beautiful spot," she said.

1329 -16

487-9-24-1907

488-9-24-1907

Mile 235: The expanse of the Illinois River from Buffalo Rock. The bluff, on the northern edge of the river, is now part of Buffalo Rock State Park, just west of Ottawa in LaSalle County. No known studies were ever conducted in the 1890s on the impact that the Drainage Canal might have downstate. Environmental impact statements were not imagined for another seven decades. This stretch of river changed dramatically when the nearby Starved Rock Lock and Dam opened in 1933. Several islands were submerged.

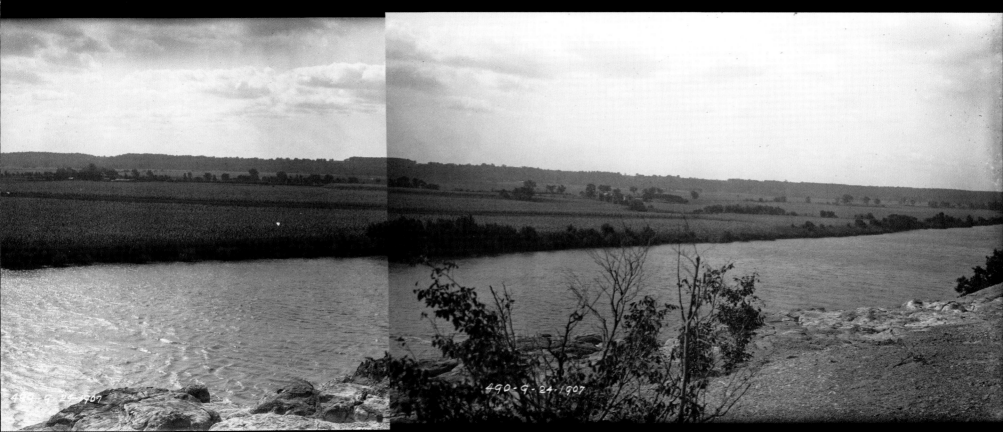
490-G-24-1907

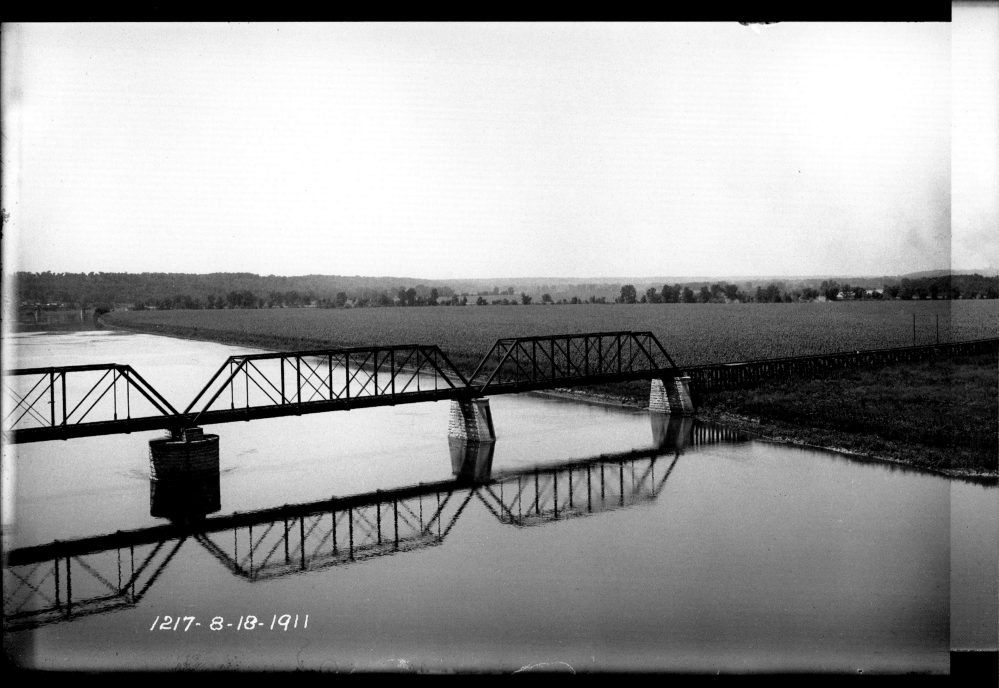

1217- 8-18-1911

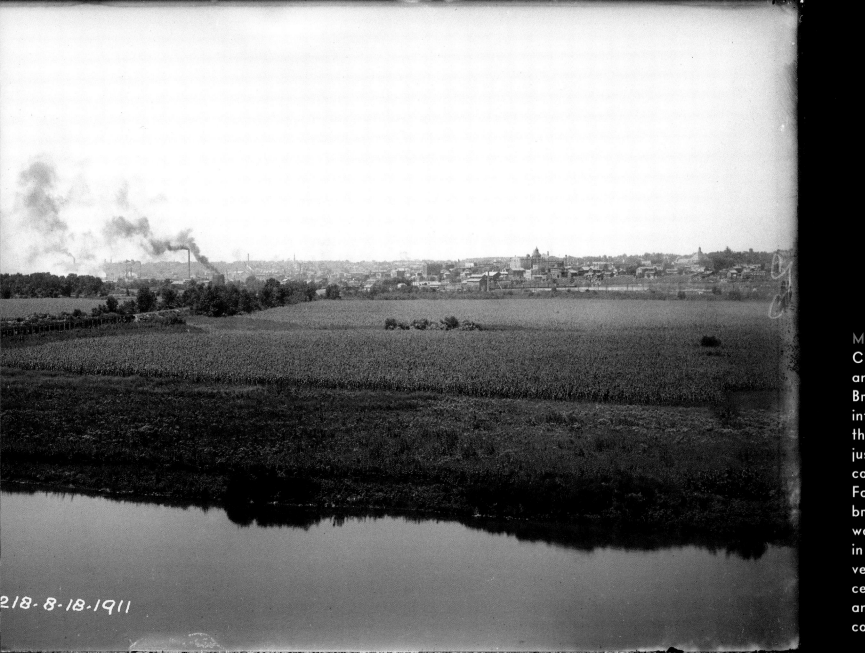

218·8·18·1911

Mile 240: **The Chicago, Burlington and Quincy Railroad Bridge heading into Ottawa over the Illinois River just west of the confluence of the Fox River. The bridge, built in 1898, was reconstructed in 1932 with a vertical lift in the center so that wider and taller barges could pass under it.**

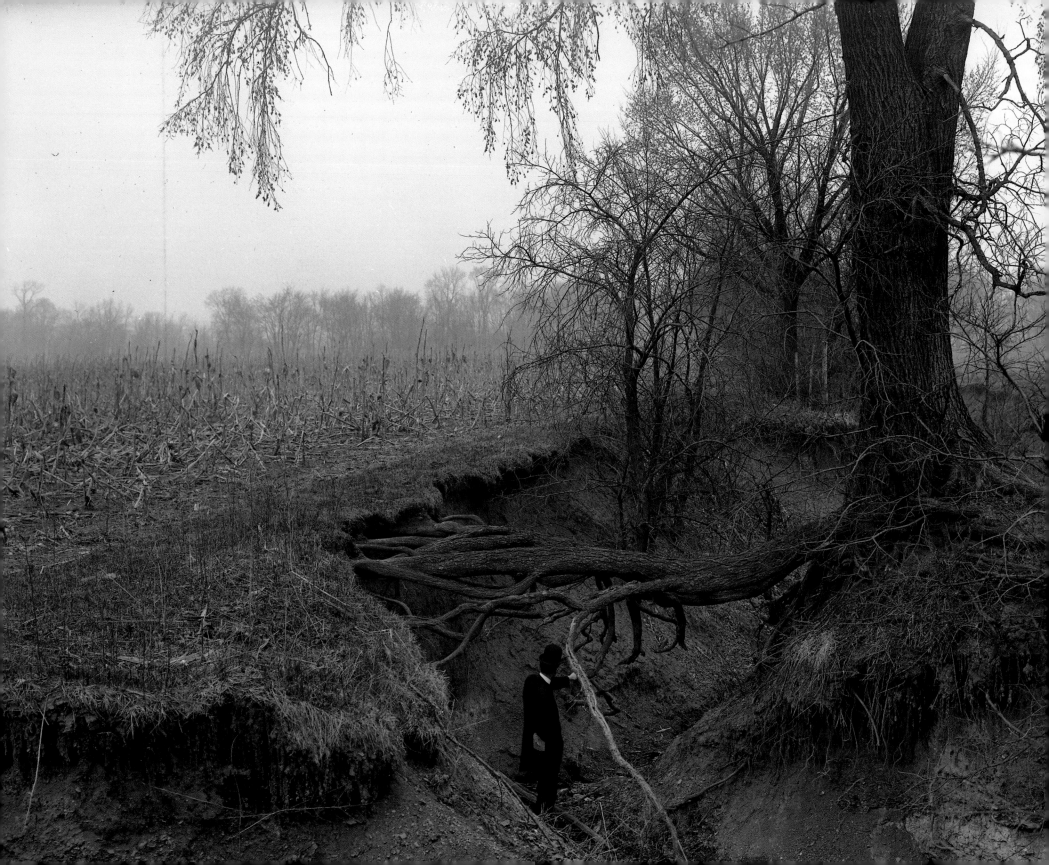

1030-3-29-1910

Mile 241: Sanitary District attorney Walter E. Beebe, who worked as a claims agent in the Illinois Valley, checks erosion and flooding on the south side of the Illinois River in 1910. He was on the property of James Gentleman, who sued the district for $12,000 in 1905 and won a $5,000 verdict in 1912. Gentleman spent the next two years trying to get the district to pay his attorney fees. In 1919, the Illinois Natural History Survey studied the changes on the river since the opening of the Main Channel. Most striking were deadened trees and shrubs along the banks. "Other important effects are beginning to appear as these dead trees weaken and fall into the water of the stagnant lakes, fouling them, in the hottest weather, with the products of vegetable decay," wrote researchers Stephen A. Forbes and Robert Earl Richardson.

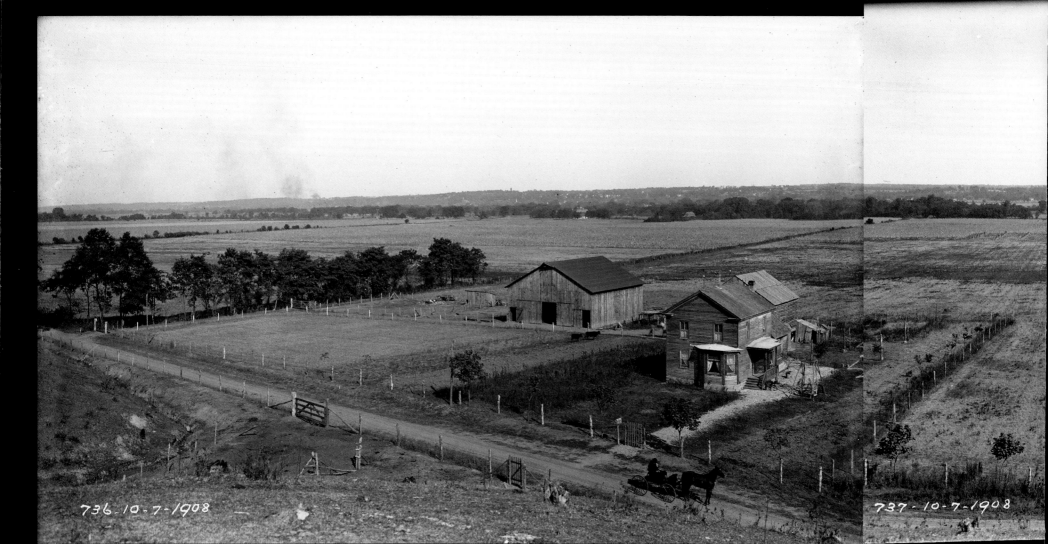

736. 10-7-1908

737- 10-7-1908

738-10-7-1908

Mile 248: A horse and buggy heads past the J. W. Albeck residence in LaSalle County in this view looking north from a bluff toward the Illinois River with Marseilles in the background. Stephen Forbes, first director of the Illinois Natural History Survey who studied the river since 1876, was dismayed about the effect of sewage pollution when he inspected this stretch in the summer of 1911 and spring of 1912. He wrote, "During July the river between its origin and the Marseilles Dam is practically barren of fishes, bubbling with gases of decomposition, and full of floating organic matter, and the bottom is in many places deep with foul-smelling mud from which large bubbles of offensive gas escape when stirred."

117-G-28.05

112·9·28·05

◄ Mile 258: The Carlin property on the south side of the Illinois River near Morris in Grundy County. John W. Carlin, whose father moved to the county to build the Illinois and Michigan Canal, asked for $100,000 in flood damages in a suit filed in 1903. He died in 1918, and his estate settled for $23,000 two years later.

▲ Mile 261: An old homestead up the river on the Carlin property. Researchers from the Illinois Natural History Survey found that sewage from Chicago created five- or six-foot-deep deposits of sludge in places along this sixteen-mile stretch of river between Marseilles and Morris. "It is clear that neither plants nor animals requiring oxygen could live in these sediments at the the bottom of the stream," they wrote in 1914. The pollution from Chicago soon created a disaster of "catastrophic proportions," according to survey scientists. By 1922, researchers wrote that the Illinois was "essentially a dead river."

126.9.29.05

Mile 266: The Mazon River, a tributary that flows into the Illinois River just south of Morris, contains one of the largest and most diverse assemblages of fossils in the world. It is where the Illinois state fossil, the Tully Monster, was discovered. Although the creek was picturesque, the nearby Illinois River was toxic. Ecologists Stephen Forbes and Robert Richardson could find only a single frog, three turtles and a few fish in 1912. "On the night of August 19," they wrote in the Illinois Natural History Survey Bulletin, "a heavy rain, which flooded the small creeks, washed fishes out into the river, where they became sick from sewage and could be picked up easily with a dip-net."

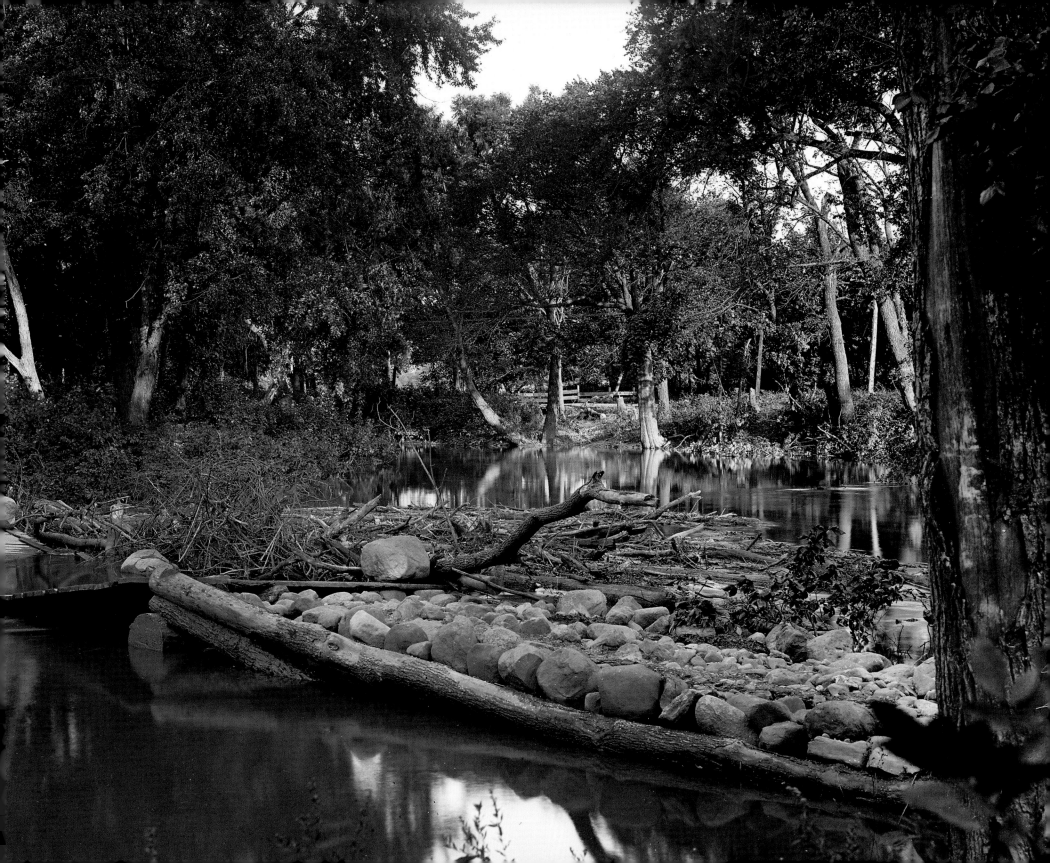

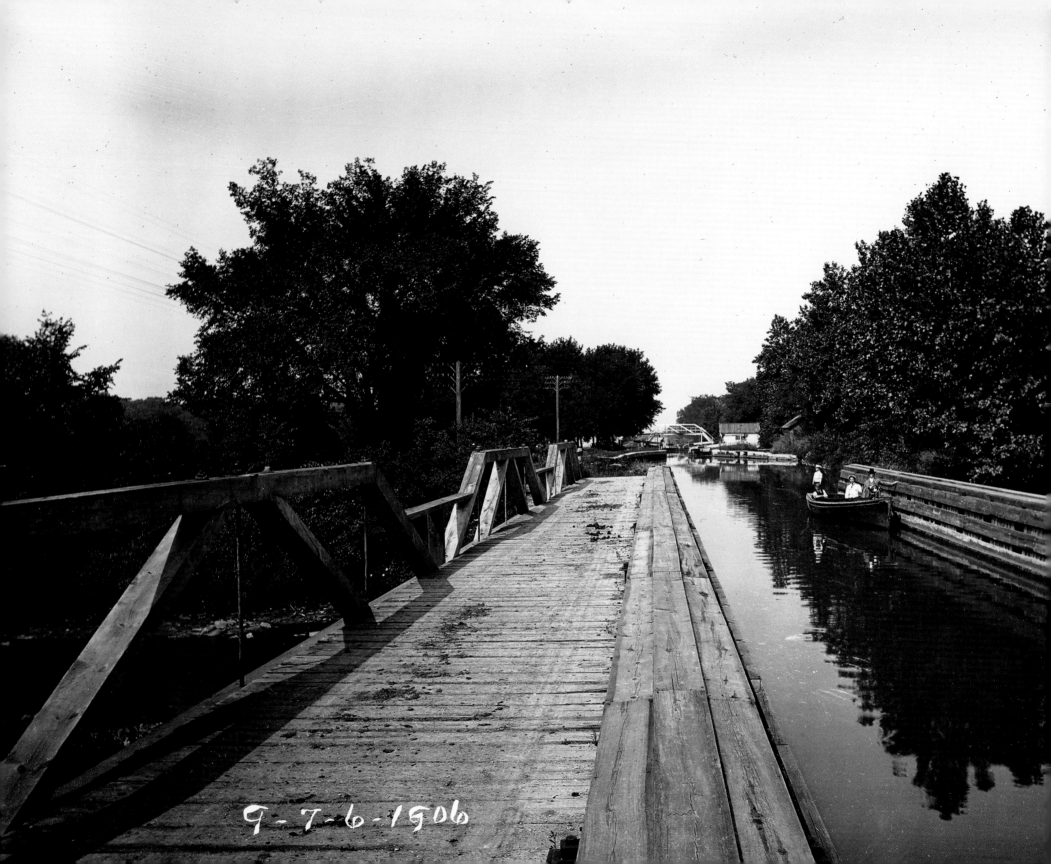
9-7-6-1906

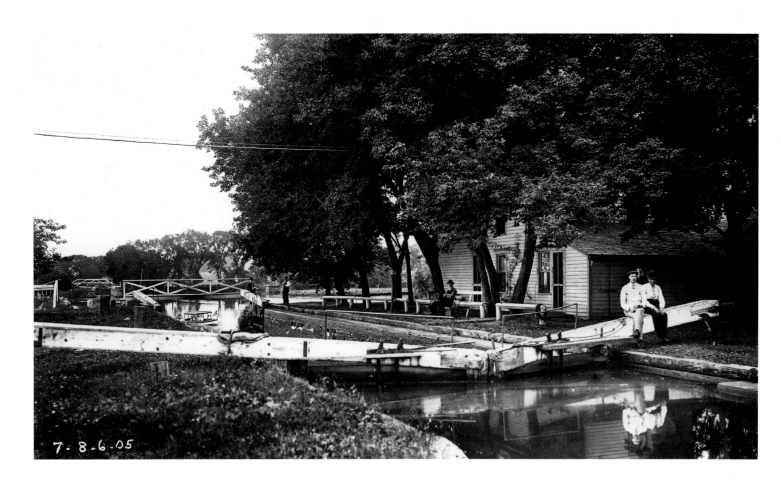

7-8-6-05

◄ Mile 269: A wooden aqueduct made it possible for the Illinois and Michigan Canal to cross the Aux Sable Creek east of Morris. To the west of the aqueduct, in the background, was Lock 8. Four aqueducts were built over rivers and creeks, including a four-hundred-foot passage on the Fox River just north of Ottawa. The I&M was in little use after the construction of the Drainage Canal, and it closed to boat traffic in 1933, the year the Illinois Waterway opened. Some of the old canal has been restored, but much was filled in. The four water bridges survive as remnants

▲ Mile 277: Lock 6 of the I&M Canal near Channahon. The DuPage River is in the background. Fifteen identical locks were built to improve navigation on the canal by lifting or lowering boats along the ninety-six-mile stretch between Chicago and LaSalle. Two hinged miter gates that controlled each end of the lock were opened and closed manually by lock tenders, who lived nearby. The tender's house on Lock 6 still exists.

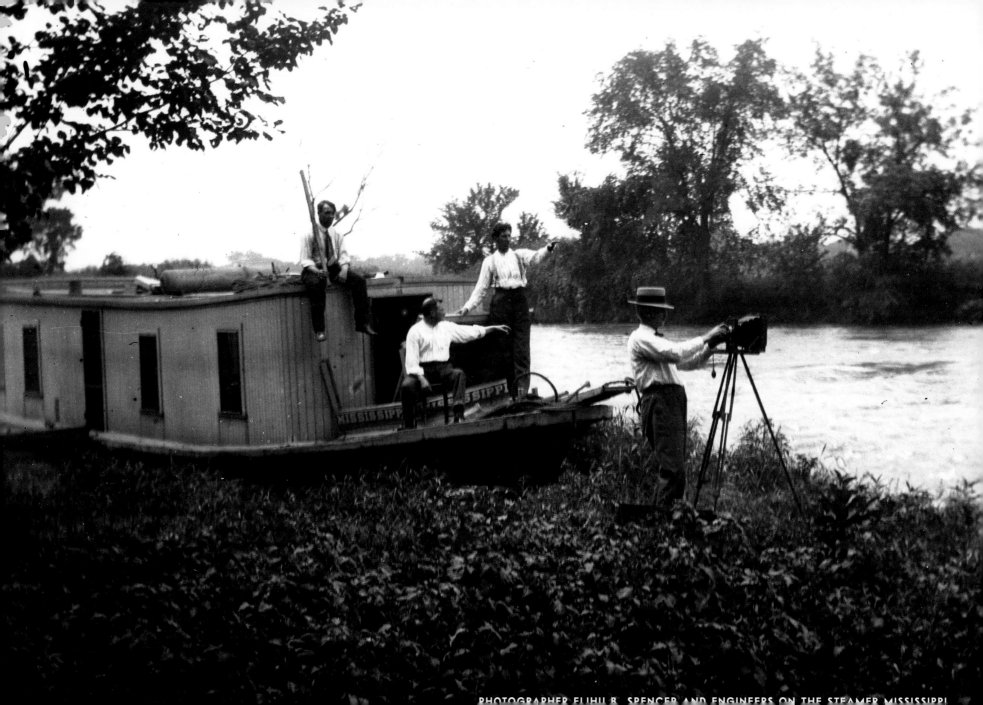

PHOTOGRAPHER ELIHU B. SPENCER AND ENGINEERS ON THE STEAMER MISSISSIPPI

Photographers in the early twentieth century captured images on heavy plates of photosensitive glass and had to haul bulky view cameras on tripods. Those hired by the Sanitary District also carried small field books to record the location and their impressions at each stop. Once back in Chicago, they developed their glass plates and made prints that were bound in albums for district engineers and lawyers.

At least seven photographers—William M. Christie, Elihu B. Spencer, A. C. Paterson, Carlton R. Dart, B. E. Grant, C. C. Featherly, and Peter Fish—have been identified as the creators of the photos from 1894 to 1928 in the Sanitary District archives. Their names are hard to come by, occasionally scratched on negatives or stamped on their field books.

The most skilled and prolific photographer was Elihu Spencer. The majority of the photos in this book are his. Spencer replaced William Christie when Christie was laid off in 1900, months after the Main Channel opened. That must have been a surprise, since Christie's work had won a top prize at the Exposition Universelle in Paris earlier that year. Spencer, who went by E.B., was born in Oswego, New York, in 1850. His father, also Elihu Spencer, was a photographer who moved his family to Canada to open a gallery and studio in Ottawa. The family moved again, this time to Chicago, around 1870, the year twenty-year-old E.B. was first listed in the city directory as a photographer. In 1894, he opened a photo gallery in the Loop. He worked for the Sanitary District from 1898, at $125 a month as a photographer (the same pay as a stenographer), to 1915 and took almost all of the district's photographs during that time.

Spencer was given specific assignments, but he often digressed, spending time to set up compositions more for himself than specifically for the district. Yet he was first and foremost a documenter: he made perfect notes (he never erased) of where and when his photos were taken and the atmospheric conditions. His photographs are technically perfect, and his panoramas match up with remarkable precision.

Alexander C. Paterson, who went by A.C., took over for Spencer in 1915 or 1916. He did not bring to the job the same skill. Born in Chicago to Scottish immigrants in 1859, he is listed in the census in 1880 as a druggist and in 1894 as the owner of A. C. Paterson & Co., Real Estate & Renting. In 1910, about five years before he joined the Sanitary District, he was listed as a commercial photographer.

Paterson's negatives are inferior to Christie's. Many were poorly exposed. His development was inconsistent and his negatives are often dense. But Paterson stayed on the job for nine years and produced photographs

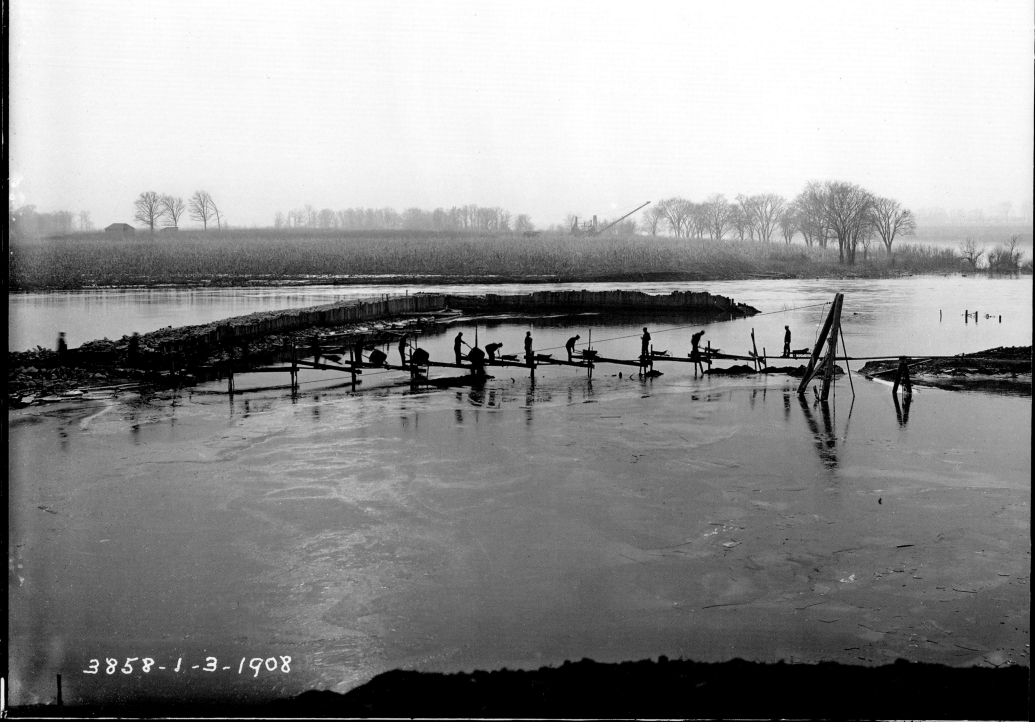

3858-1-3-1908

◄ Mile 274: Workers repair a cofferdam near Dresden Heights on the Des Plaines River, just upstream from its confluence with the Kankakee to form the Illinois River. The cofferdam, used to hold back water during construction projects, was damaged by a flood in 1908. It was being used by the Economy Light and Power Company of Joliet to build a dam on the river, but litigation stalled construction. The men on the catwalk were attempting to reach the odd structure on the right. During the 1890s, thirteen miles of the Des Plaines River was rebuilt as part of the Drainage Canal project.

► Mile 279: Just east of Channahon is the tiny town of Millsdale, near the huge Joliet Arsenal property. The federal government started acquiring land to build the arsenal in 1941, and by the end of World War II more than ten thousand people were at work producing bombs, shells, mines, and TNT. The arsenal was deactivated after the war but was reopened and expanded to make weapons during the Korean and Vietnam Wars. Much of the arsenal land was converted in 1997 to the Midewin National Tallgrass Prairie, the largest prairie restoration project east of the Mississippi River and one of the nation's first prairie parks. This photo was taken in 1903.

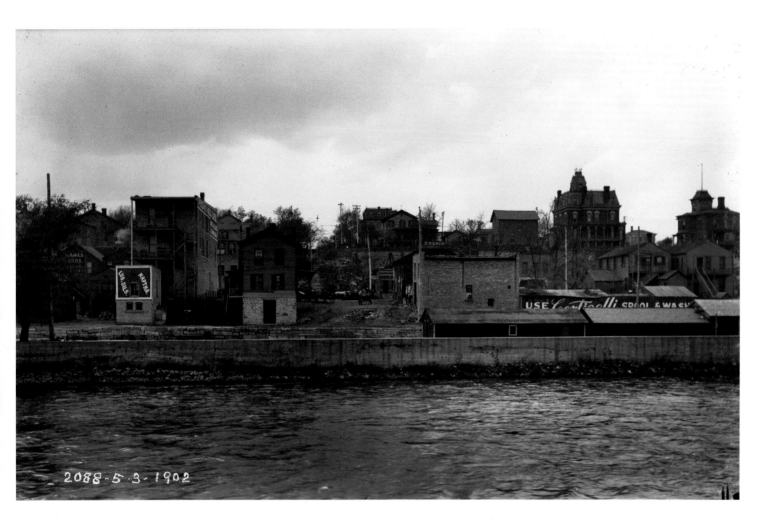

2088-5-3-1902

▲ Mile 289: The Des Plaines River from Lockport to Joliet was straightened, widened, and deepened from 1898 to 1901, and the Main Channel was extended four miles from 1903 to 1907 to create waterpower for a new hydroelectric powerhouse south of Lockport. Sanitary District photographers documented the length of downtown Joliet after building a concrete retaining wall through town.

▶ A view from the Jefferson Street Bridge looking north shows the removal of the old Illinois and Michigan Canal lock in the Des Plaines River. The Sanitary District replaced the lock to increase the flow of water. The new steel bridge replaced a stone arch bridge that obstructed the river.

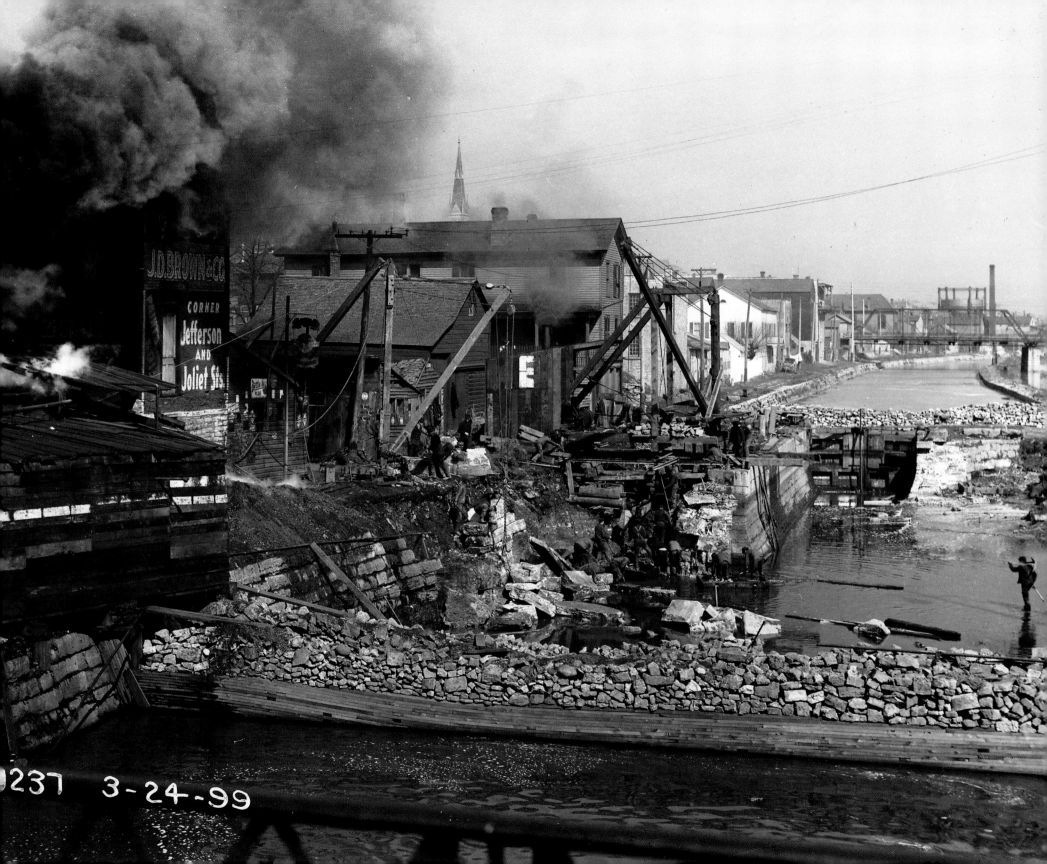

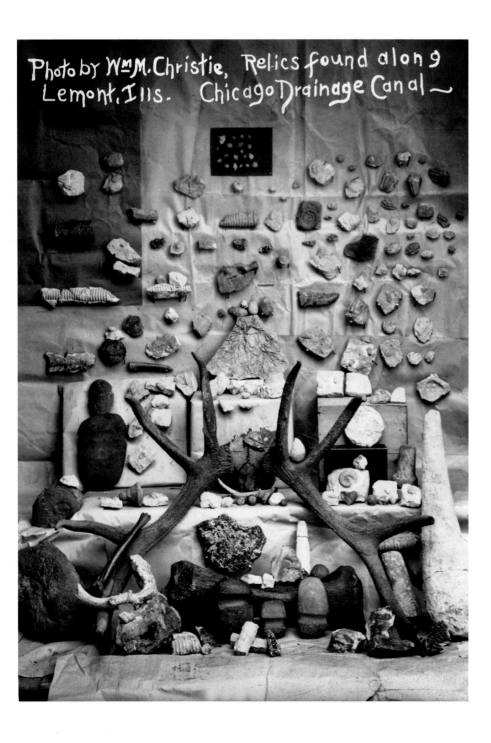

Photo by Wm M. Christie, Relics found along
Lemont, Ills. Chicago Drainage Canal

◄ Workers uncovered thousands of years' worth of natural history in the alluvial deposits that were removed for the canal. Fossils, buried timber, a stone ax, a flintlock pistol, Native American tools and pottery, as well as bones of buffalo, antelope, and mastodon, were found, according to Ossian Guthrie, who called the relics "a panorama of the ice age."

► Mile 296: The canal passes through the tiny town of Romeo, which was once the twin city of Juliet. The name Juliet was changed in 1842 at the urging of President Martin Van Buren, who insisted that the town recognize the accomplishments of the explorer Louis Jolliet. Romeo disappeared but came back after World War II as Romeoville. The Romeo Road Bridge, built in 1899, was replaced by a modern high-level highway bridge, but it has been preserved along the nearby Centennial Trail nature path. An electronic barrier has been installed in this area, just beyond the bridge, to control the spread of Asian carp. The Great Two-Mile Curve angles northeast toward Lemont. The photo was taken in 1898.

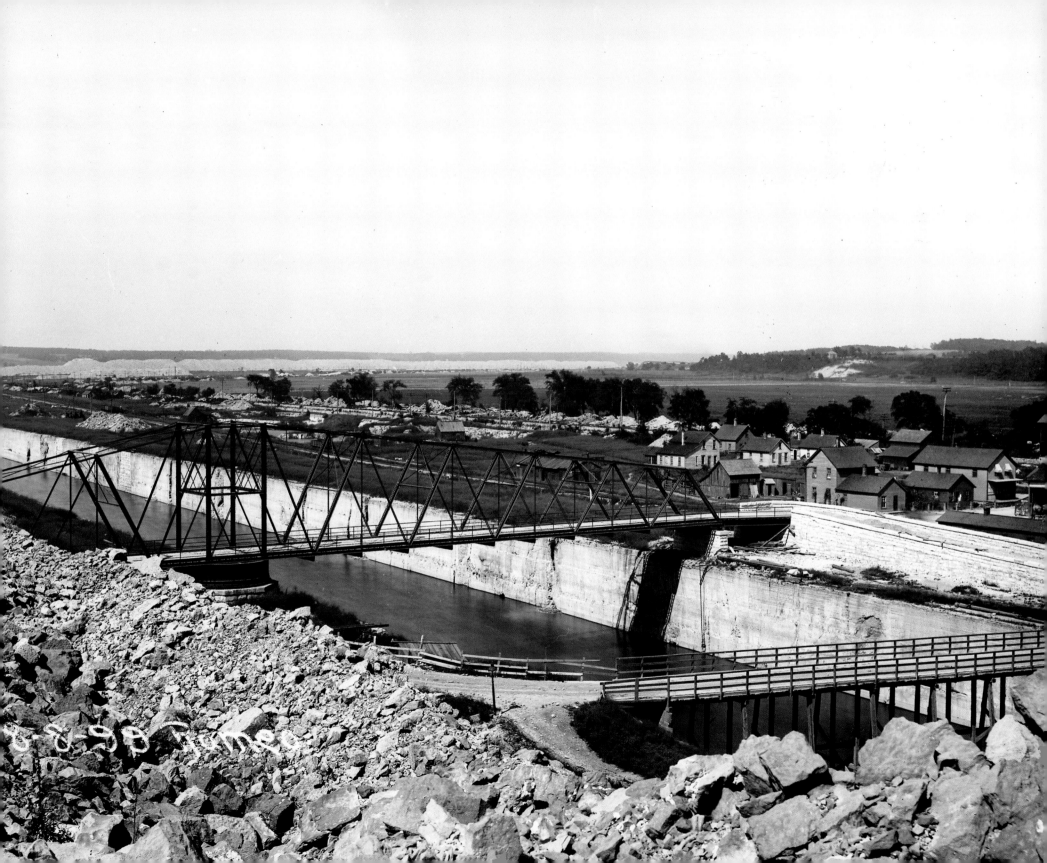

Feeder creeks of the Calumet-Sag Channel near Worth Road. The sixteen-mile channel, finished in 1922, reversed the Calumet rivers, sending their flow west to the Sanitary and Ship Canal at Sag Junction. Wrote outdoors columnist Larry St. John: "If you go to the Sag now you will see, instead of marsh land and water, a burned over country dry as a bone." The place looks like a miniature Panama Canal, he continued. Even the feeder creeks are gone. "We asked a workman why they were doing all this digging and blasting," St. John wrote. "He didn't know, but we hope the engineers do."

7117
PLATE
3

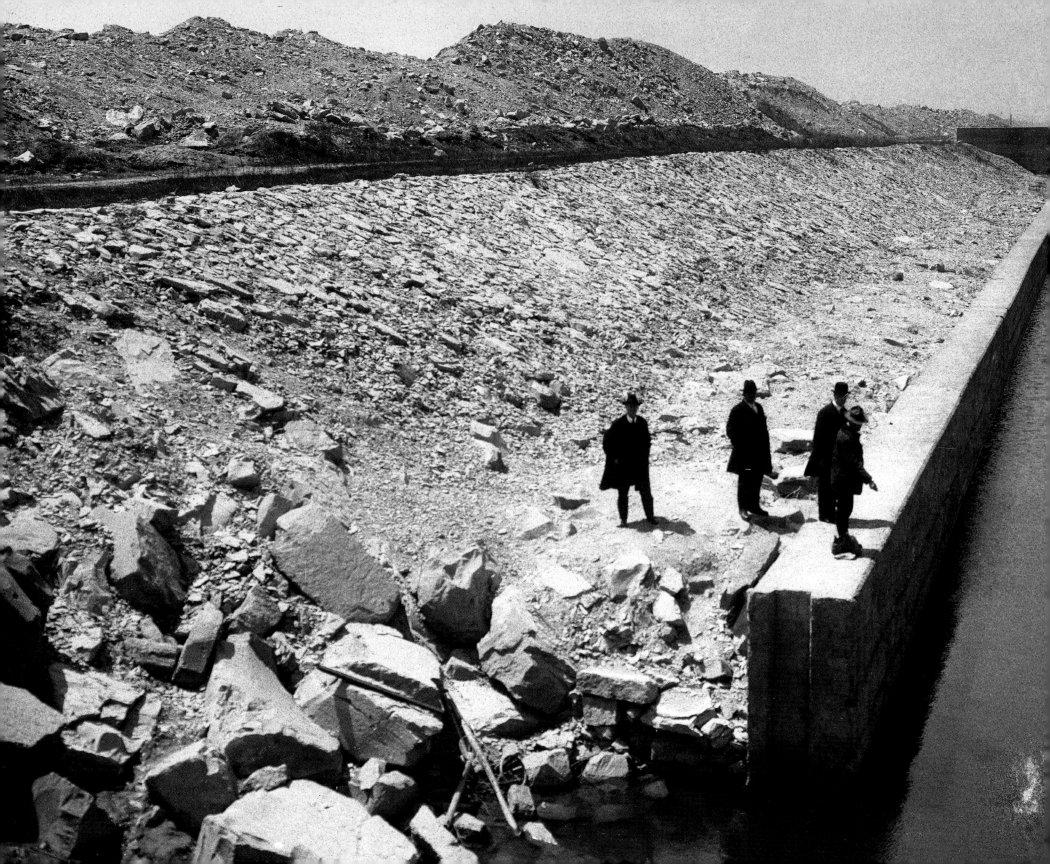

▲ Western Avenue Bridge over the Cal-Sag Channel in Blue Island. The bridge was replaced when the channel was widened from 60 to 225 feet around 1960 to make it possible for larger boats and ships to navigate the canal.

◄ Sanitary District investigator tosses a rock to show where a body was found in the Cal-Sag Channel near California Avenue in Blue Island. The photo was taken in 1920, before the canal officially opened. The old Kedzie Avenue Bridge is in the background. It, too, was replaced when the channel was widened.

Mile 314: Clearing Mud Lake, original portage between the Des Plaines and the Chicago Rivers. Workers burned heavy slough grass with oil decades before the value of wetlands for plant and animal conservation and flood control was understood. "The mud was very deep," wrote Gurdon Hubbard, a Chicago settler about the early crossings, "and along the edge of the lake grew tallgrass and wild rice, often reaching above a man's head, and so strong and dense it was almost impossible to walk through."

9318
July - 24 - 22 -

9316
JULY-24-22

5033-11-10-1914

290-"0" 8-17-94

◄ Mile 319.5: Thirty miles of transmission lines connected the Sanitary District's Lockport powerhouse to Chicago. The district built the powerhouse to take advantage of the drop in water elevation between Lockport and Joliet. Electric current was transmitted to Chicago, where it was used to light city streets and parks and provide power for district facilities. This view is of the Chicago Madison & Northern Railroad Bridge, which crosses the Main Channel east of Kedzie Avenue. It was one of thirteen movable bridges that crossed the channel.

▲ Mile 320.6: A train nears the Drainage Canal just west of Western Avenue. This area is now highly industrial.

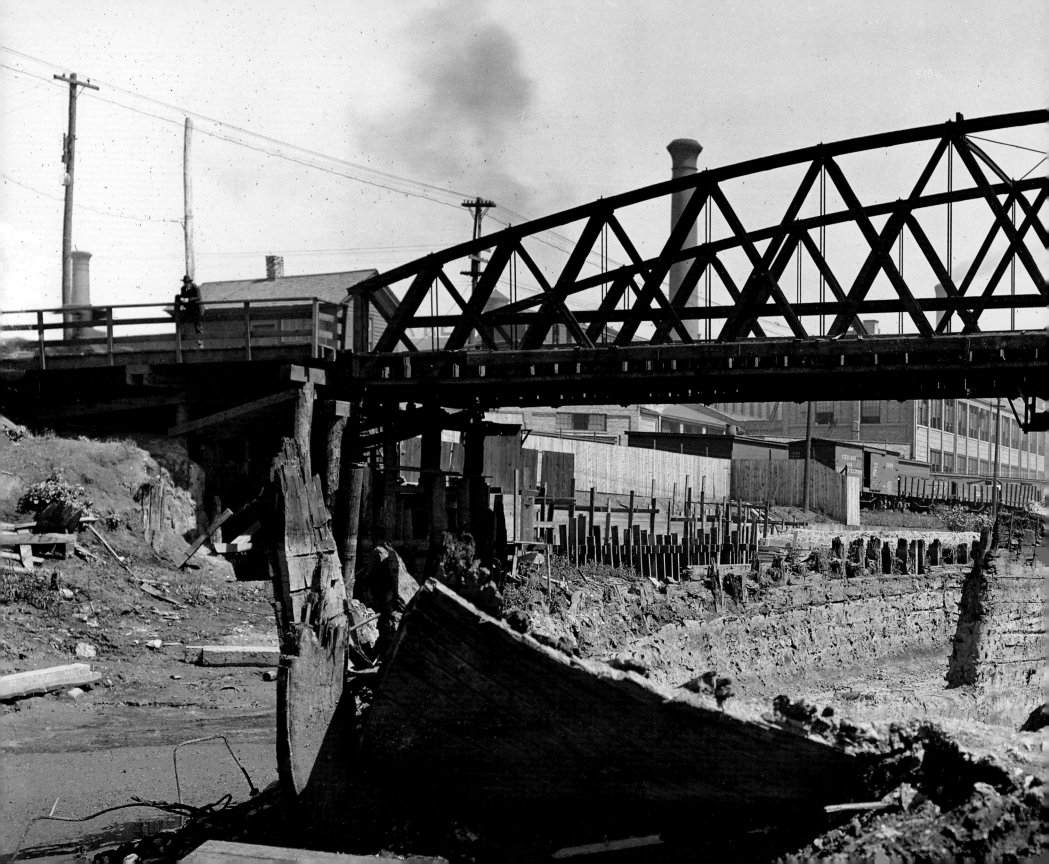

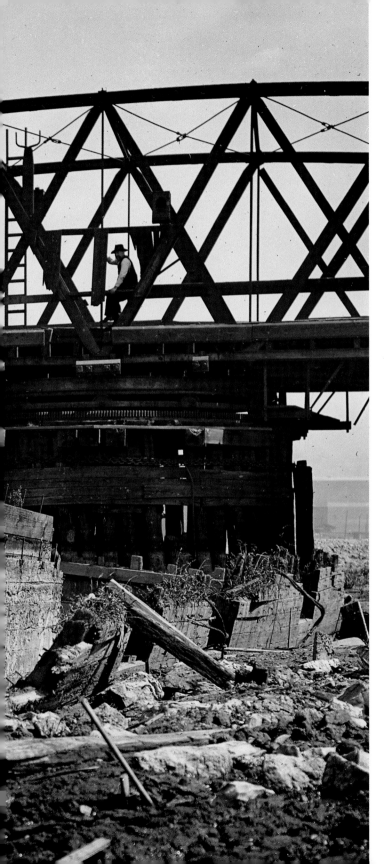

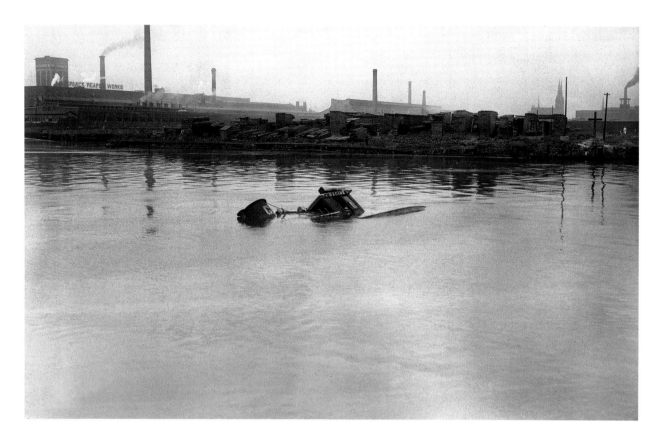

◄ Near Mile 320.5: A boat is unearthed in 1905 near the Western Avenue Bridge on the West Fork of the South Branch of the Chicago River. The bridge was a nonmechanized swing bridge, opened by tugboats. The West Fork was drained at this time for a construction project.

▲ Mile 321.1: The tugboat RACINE sinks slowly on the Chicago River near Robey Street (now Damen Avenue), the start of the Main Channel. A cross marks where Father Jacques Marquette camped during the winter of 1674–1675. In the background is the McCormick Reaper Works, where a strike in 1886 led to the Haymarket riot.

Mile 321.5: The Bridgeport Lock on the Illinois and Michigan Canal, near Ashland Avenue and Twenty-Seventh Street. The photo at right shows the east gate; the photo above shows the west gate. The CHICAGO TRIBUNE wrote in 1900 that more than 2,000 men were hired by the Sanitary District to build the locks, far more than were needed. "There is no doubt that certain trustees sent strikers and ward heelers down there to work, and that their incapacity was a great hardship to the engineer," Trustee Bernard A. Eckhart told a reporter. "They were neither useful nor ornament, but they drew their pay." In 1913, Illinois Governor Edward Dunne suggested the old canal be drained, dredged, and converted into a subway track for electric and steam trains approaching the city from the west. The location of the lock is marked today by Canal Origins Park, immediately south of the South Branch turning basin.

► Near Mile 321.5: The infamous Stockyards Slip, an open sewer along Thirty-Ninth Street (now Pershing Road) that connected the stockyards to the South Fork of the South Branch of the Chicago River at Racine Avenue. This photo shows the slip looking east from Morgan Street after it was emptied in preparation for building a covered sewer along the route. The smell from the yards and the slip persuaded many people of means to move as far north as possible. Wrote Upton Sinclair in THE JUNGLE: "Here and there the grease and filth have caked solid, and the creek looks like a bed of lava; chickens walk about on it, feeding, and many times an unwary stranger has started to stroll across, and vanished temporarily."

10846
JULY·1·24·

▲ Sewers from the Union Stockyards flow into the South Fork of the South Branch, known as Bubbly Creek. Meatpackers dumped so much blood and the remains of so many animals into the creek that it started bubbling with methane and hydrogen sulfide gases. Even though the dumping stopped when the stockyards closed in 1968, the creek still bubbles as it wanders toward the Sanitary and Ship Canal. This is near Thirty-Seventh Street west of Racine Avenue.

352G-11-1-1906

◄ Near Mile 321.5: The West Fork of the South Branch, which no longer exists. This was the portage route that connected the Chicago River to Mud Lake and the Des Plaines River. The West Fork was filled in starting in 1935 because it was seldom used, a move that altered several Southwest Side neighborhoods. Five bridges were removed, and streets that ended at the river were connected and widened.

▲ Mile 321.8: The Chicago River looking north from the turning basin with the Loomis Street Bridge to the right.

2352-6-12-1903

Mile 321.8: Lumberyards along Sampson's and Stetson's Slips on the South Branch between Loomis and Throop Streets. Wholesale lumberyards were built along man-made slips on twelve miles of docks that lined the Chicago River. During the late nineteenth century, Chicago was the largest lumber market in the world, connecting the forests of Michigan and Wisconsin to the burgeoning West. The city of lumber was awash with railroad tracks, beer saloons, and the sweet scent of freshly cut pine. By the 1920s, with many of the northern forests exhausted, Chicago was no longer the nation's distribution center, but the district persisted well into the twentieth century.

3531-11-1-1906

▲ Mile 321.9: Looking east from the Loomis Street Bridge up the Chicago River, with the Throop Street Bridge in the background. Seventeen huge tanks, called gas holders, stored gas and served as landmarks in neighborhoods around the Chicago metropolitan area. The floating gas holder structures raised up to thirty stories and lowered like an accordion depending on the amount stored.

▶ Another view from the Loomis Bridge toward Allan's Canal. Peoples Gas, Light and Coke Company manufactured coal gas at this facility. The gas was primarily used for streetlights. The company later switched to buying and distributing natural gas, used to heat and light homes and businesses. Most of the gas holders were taken down by the 1970s. This facility closed in 1960.

3536-11-1-1

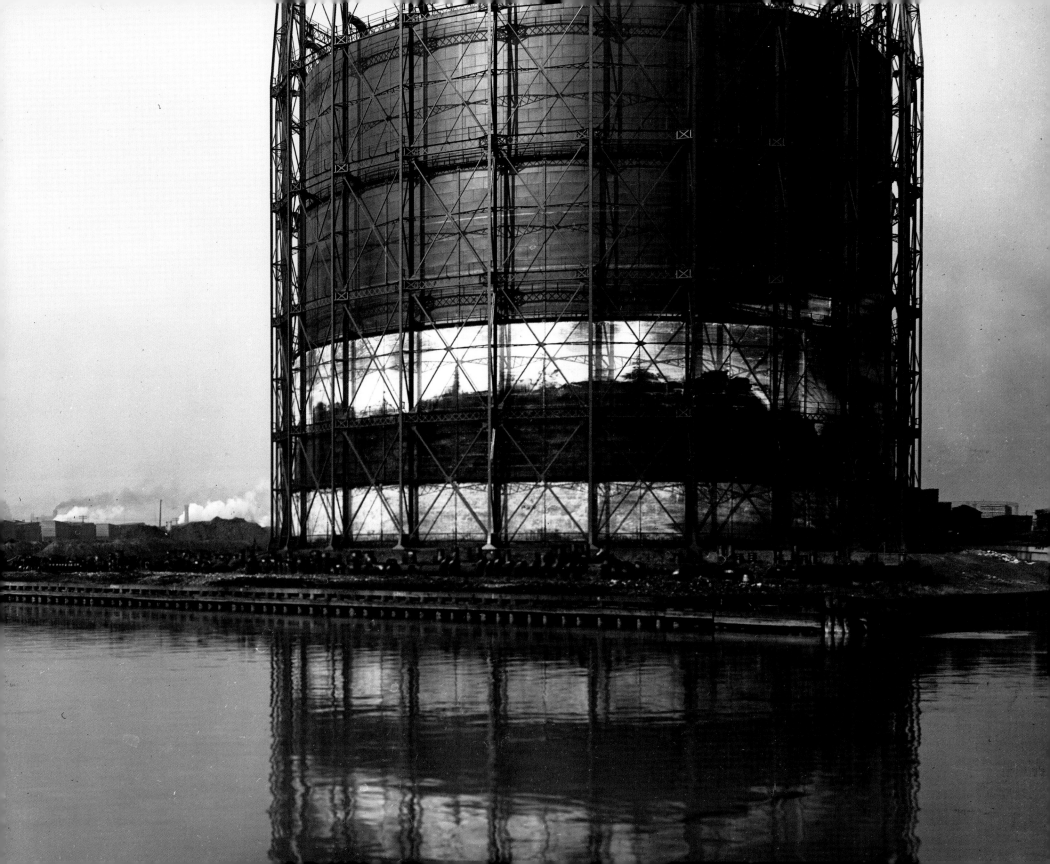

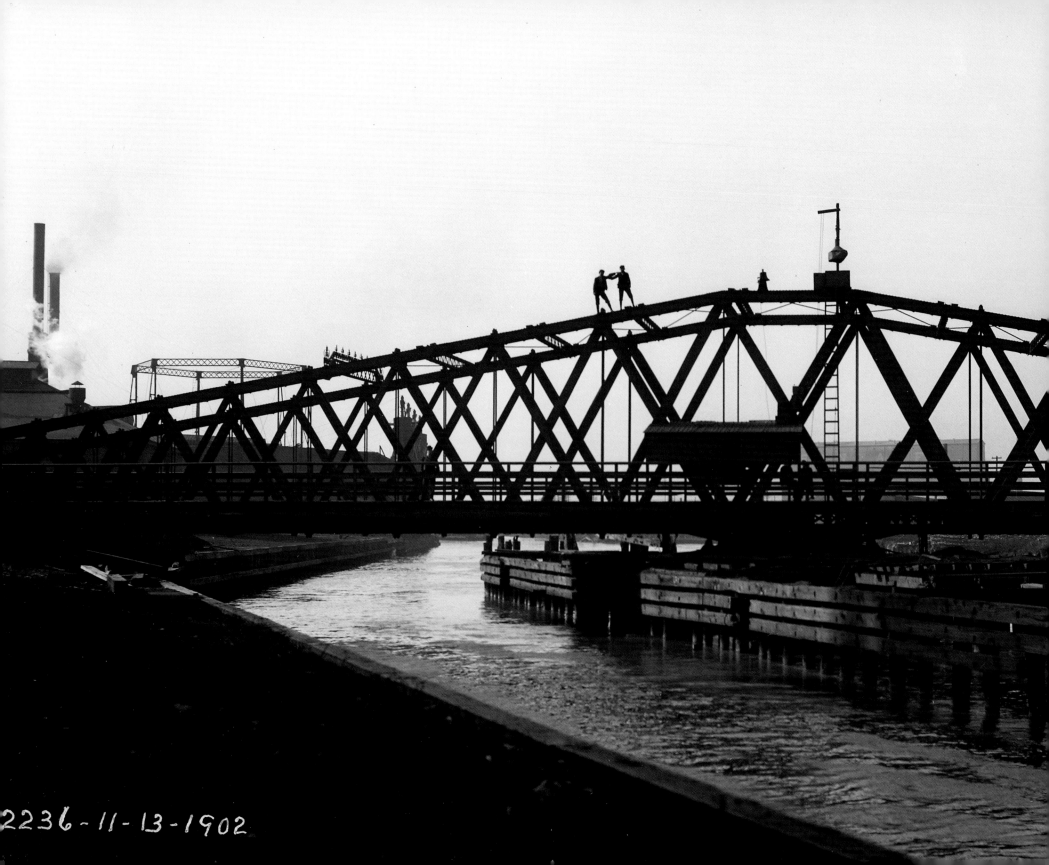

2236-11-13-1902

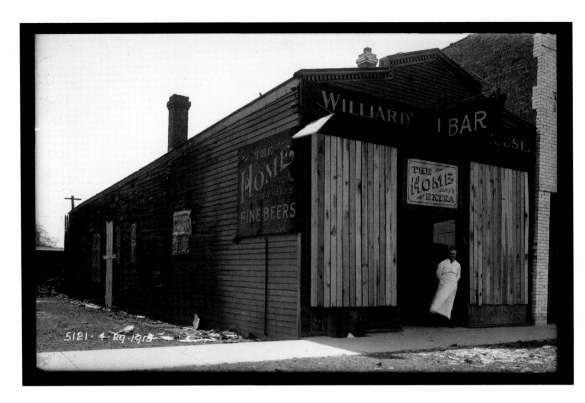

▲ A bar at 1631 W. Twelfth Street (now Roosevelt Road), north of the South Branch. The bar's owner sued the Sanitary District because its substation caught fire and singed his establishment. The district used the substation to distribute electrical power from its plant in Lockport.

◄ Mile 322: The old Loomis Street Bridge along the Main Channel. The center-pier swing bridge was protected by wooden planks called fenders. The gas holders are under construction in the background.

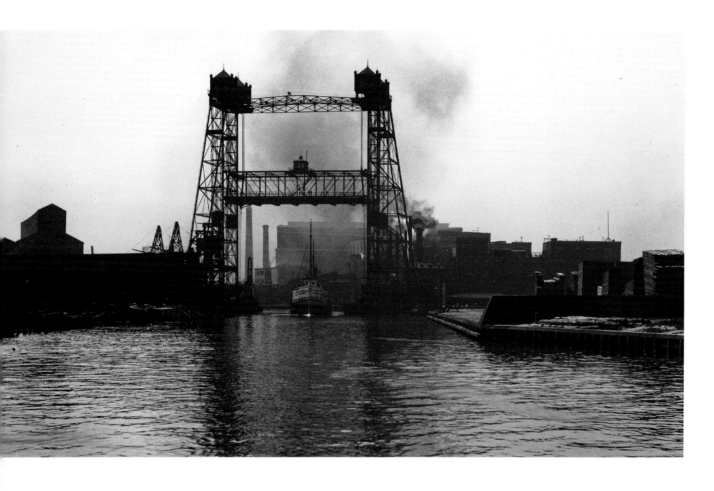

▲ Mile 322.7: The Halsted Street Bridge over the South Branch in 1900. The vertical lift bridge, built in 1894 and considered the gateway to Bridgeport, was replaced by the Sanitary District in 1934 to open up the river and because of high maintenance costs.

▶ Mile 323.3: After celebrating the increased flow of the Chicago River in 1900, river skippers soon realized the new current made navigation hazardous. The most dangerous spot was Twenty-Second Street (now Cermak Road), where the river narrowed. The decaying bridge, which survived the Chicago Fire, was an example of nineteenth-century technology that barely made it into the twentieth.

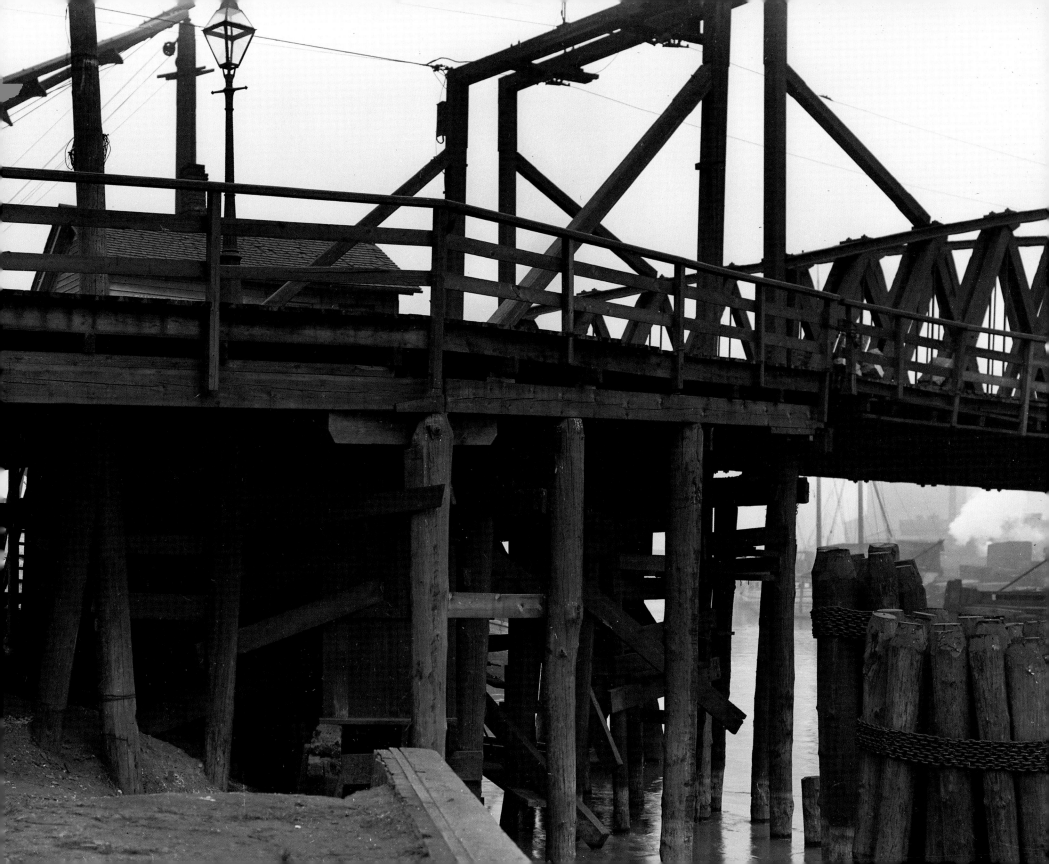

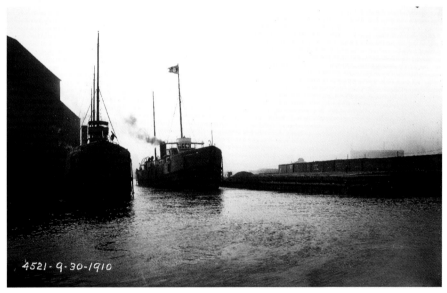

Mile 323.9: Traffic heads down the South Branch in views from the Twelfth Street Bridge looking south. The building on the east bank was the Rock Island Railroad grain elevator, torn down in the 1920s when the river was straightened.

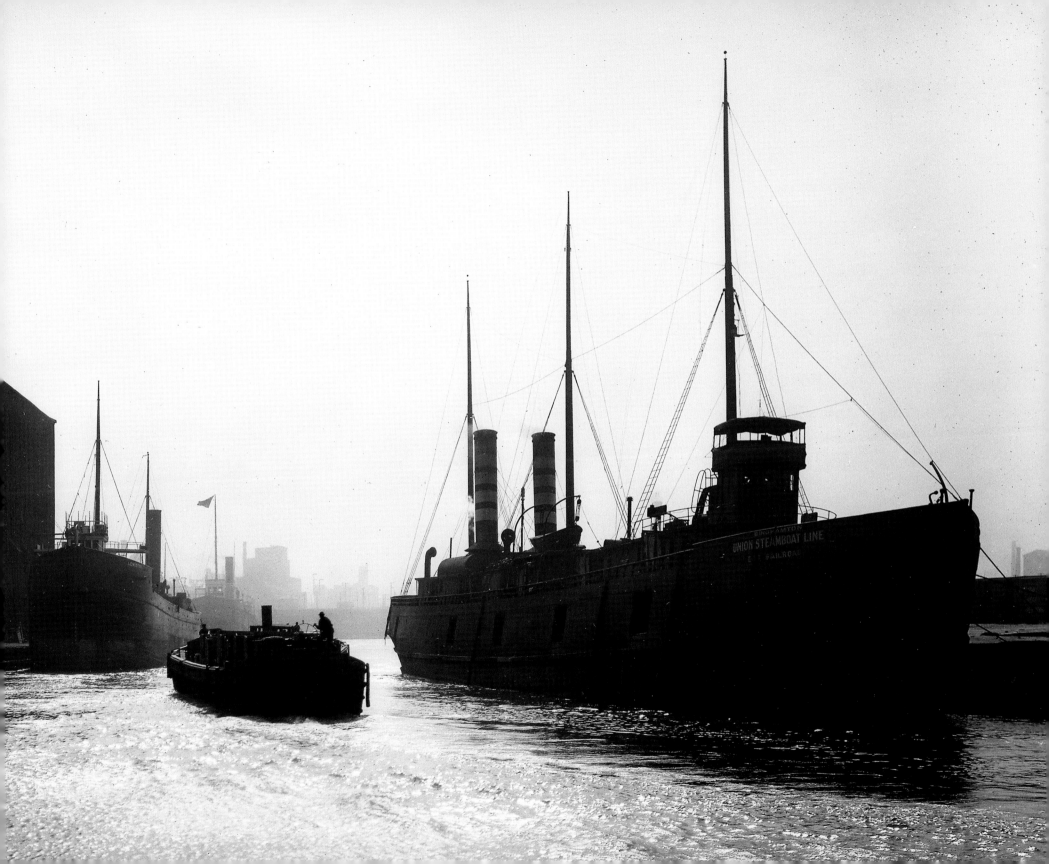

C. R. I. & P. RY.

N FREIGHT

DRIVE WAY
THESE SCALES
KEPT OPEN

2730-4-27-1904

▲ Mile 324.8: A freight warehouse in the yard of the Lake Superior and Mississippi Railroad, on the east side of the river between Taylor and Polk Streets.

◄ Mile 324.8: The Chicago, Rock Island and Pacific freight sheds on the east side of the river between Taylor and Polk Streets. The railroad, first from Chicago to cross the Mississippi River, followed the Illinois River to the Great Bend and then headed west. The Rock Island paralleled—and doomed—the Illinois and Michigan Canal because of its speed. The LaSalle Street Station shed and headhouse can be seen just beyond the row of buildings on the right down Sherman Street (now Financial Place). The dome of the Federal Building is in the background. This photo was taken from a freight car as a hand brake is seen in the foreground.

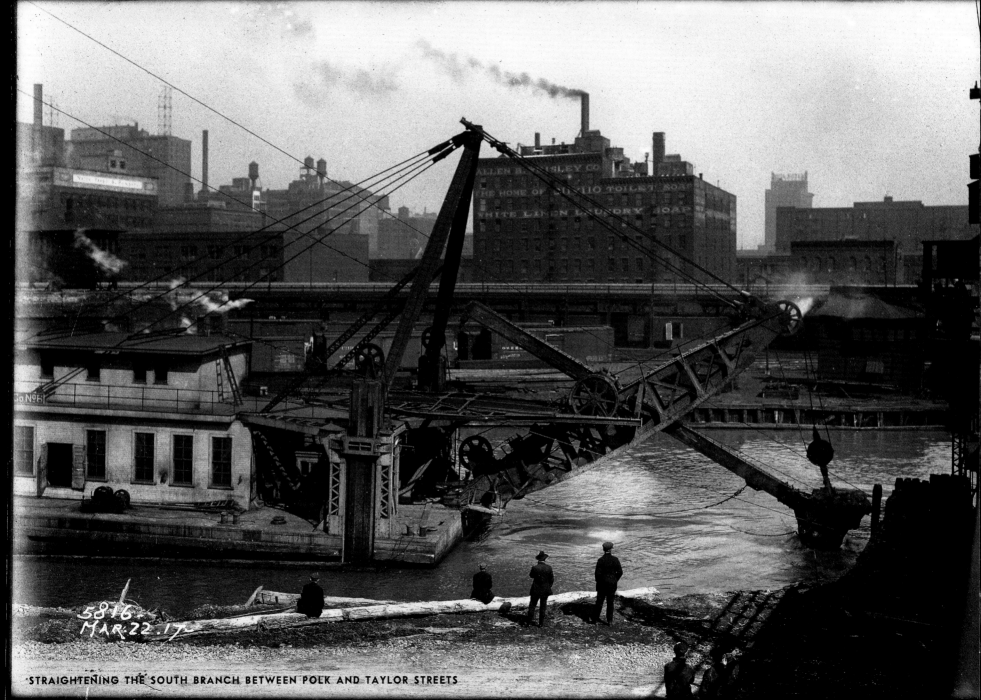

STRAIGHTENING THE SOUTH BRANCH BETWEEN POLK AND TAYLOR STREETS

To make the Drainage Canal work, the Sanitary District had to make the Chicago River work better. The five-mile link between Lake Michigan and the start of the canal, on the South Fork of the Chicago River, had to be "improved" if lake water was to flow efficiently through the Des Plaines and Illinois Rivers. So obstructions in the once curvy and sluggish Chicago River were removed.

Sanitary District photographers documented the environmental engineering on the river and the river itself during these years. Their photos show several sides of Chicago—the muscular industrial metropolis of the South Side, the transportation hub near the Loop, and a remarkably rural land along the upper stretches of the North Branch.

The federal government was in charge of straightening the Main Stem of the Chicago River, which runs from the mouth of the river at Lake Michigan straight west about a mile and a half to what is called Wolf Point, but the Sanitary District built two bridges along this stretch. At Wolf Point, the river splits into the North and South Branches. Above the North Branch, the district built the eight-mile North Shore Channel, connecting a new opening to Lake Michigan in north suburban Wilmette to the North Branch near Foster Avenue in Chicago. The canal sent lake water down the branch and collected sewage from the north end of the district. To accommodate the flow from the new channel, the district straightened, deepened, and relocated a two-mile stretch of the North Branch from Lawrence to Belmont Avenues.

On the South Branch, the Sanitary District widened and deepened four miles from Lake Street just west of the Loop to Robey Street on the Southwest Side. Downtown structures that obstructed the flow of the river were removed, and bridges that encroached on the river were replaced. The most complex job was straightening a large bow in the river from Polk to Eighteenth Streets by replacing the stretch with the new mile-long South Branch Channel.

The goal of the Sanitary District was to create a wider, deeper river that could carry more lake water at a slower velocity. One of the few engineering flaws of the Main Channel was that it created a current along the Illinois River that was above the limit for safe navigation. This improvement would slow it down.

During this time, the Sanitary District felt it had an unlimited right to Lake Michigan water. All that changed around 1907, when officials took steps to stop the district from using the lake as an open spigot. Canadian officials, seeing the level of Lake Michigan drop several inches, were worried about Great Lakes navigation. Officials in the United States were angered that the district was diverting lake water without a congressional decree. The debate about how much lake water can be diverted went on for decades—and continues today.

◄ Mile 324.8: The Union Loop Elevated Railroad powerhouse on the east bank of the Chicago River between Van Buren and Harrison Streets. It was among five buildings demolished in the area by the Sanitary District because it obstructed the river's flow.

► Mile 325.1: A ship heads past the Metropolitan West Side Elevated Railroad Bridge, with its distinctive lower arch. The Met, which served the West Side, was the only elevated company that owned its own drawbridge. The four-track bridge was called a Scherzer Rolling Lift Bridge because it reared back like a rocking chair to create a large opening on the river. The Scherzer company, based in Chicago's Monadnock Block, designed six downtown bridges for the Sanitary District to replace swing bridges across the Chicago River.

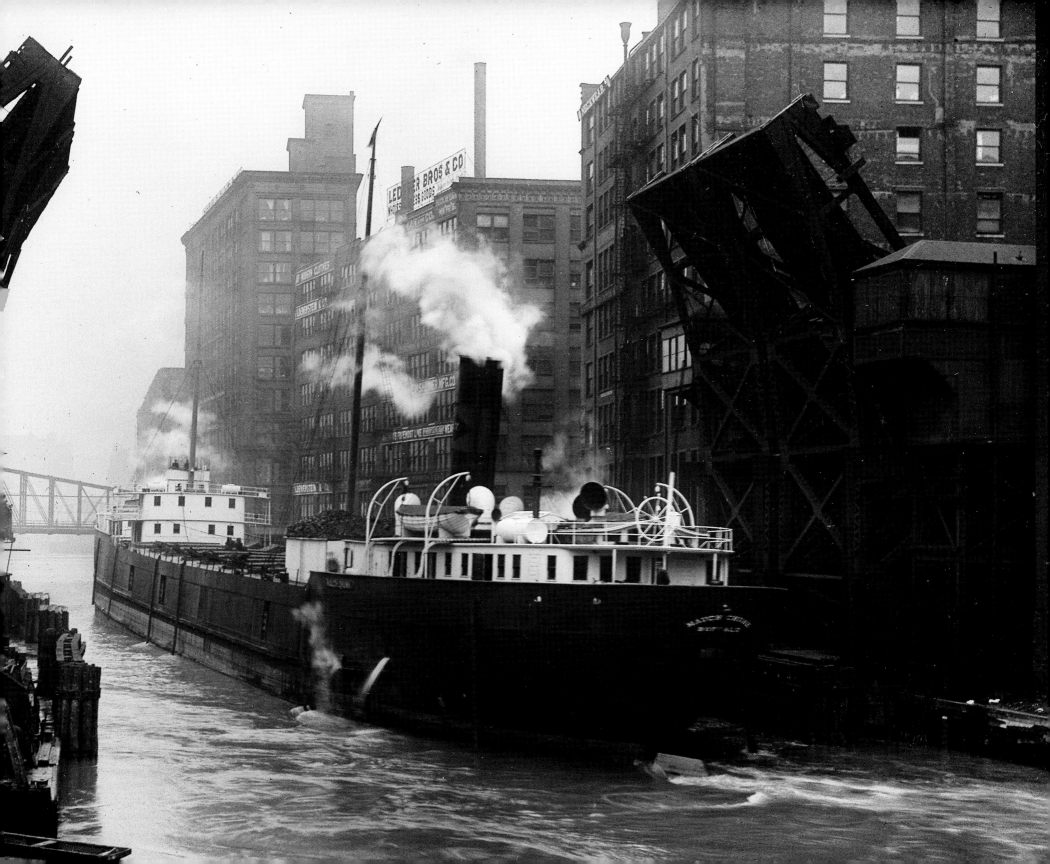

4686-10-14-1911

Mile 325.1: Before construction began, photographers documented cracks in buildings so that the Sanitary District would have proof of prior damage. These photographs were taken in advance of deep excavations for a bridge over the Chicago River. The building on the right at Jackson Boulevard and Market Street (now Wacker Drive) was in the heart of the garment manufacturing district, along the east side of the Chicago River. Loft buildings were built with open areas so workers, mostly women, could take advantage of natural light as they produced ready-to-wear clothes. A series of strikes in the 1910s led to unionization and collective bargaining among Chicago garment workers.

4929

CHILDRENS WEAR

ONINGER – HEINSHEIMER M'F'G. CO.

CHILDRENS CLOAKS AND DRESSES

MISSES ROOM AND DRESSES

JACOB MEYE & BROS.

UNDERWEAR AND HOS

JACOB MEYER & BROS.

UNDERWEAR AND HOSIERY

-1914

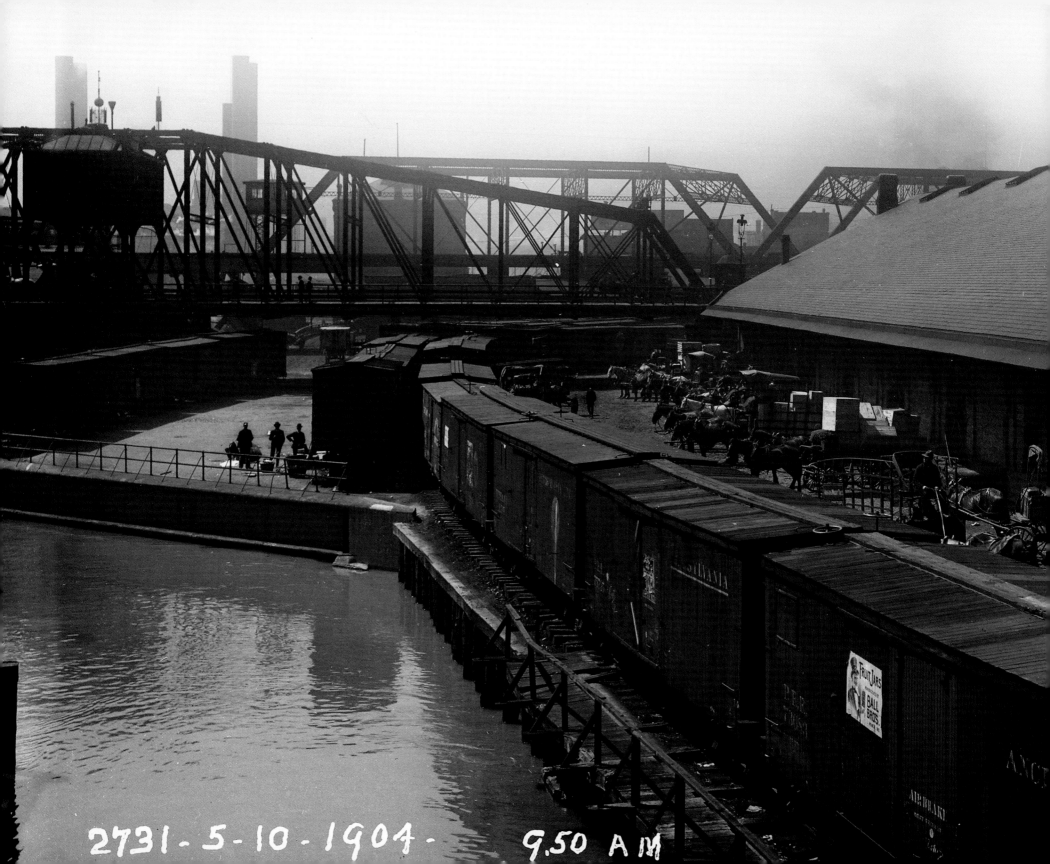

2731 - 5 - 10 - 1904 - 9.50 A M

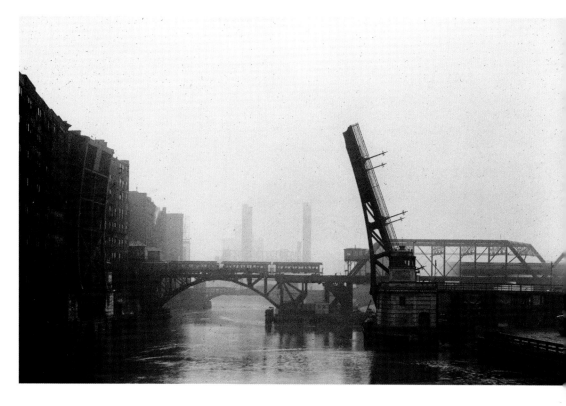

▲ Mile 325.3: A view south from the Adams Street Bridge shows the raised Jackson Street Bridge and a train crossing the Metropolitan West Side Elevated Railroad Bridge. The photo, taken in 1916, illustrates how new bridges cleared the river of major obstructions.

◄ Mile 325.3: Looking south at the Jackson Street Bridge and a rail freight yard on the west side of the river. The tracks, now used by passenger trains, have since been covered by developers who purchased air rights to build skyscrapers. Beneath the three men is an underground bypass channel built by the Sanitary District that moved Chicago River water under railroad property to Van Buren Street.

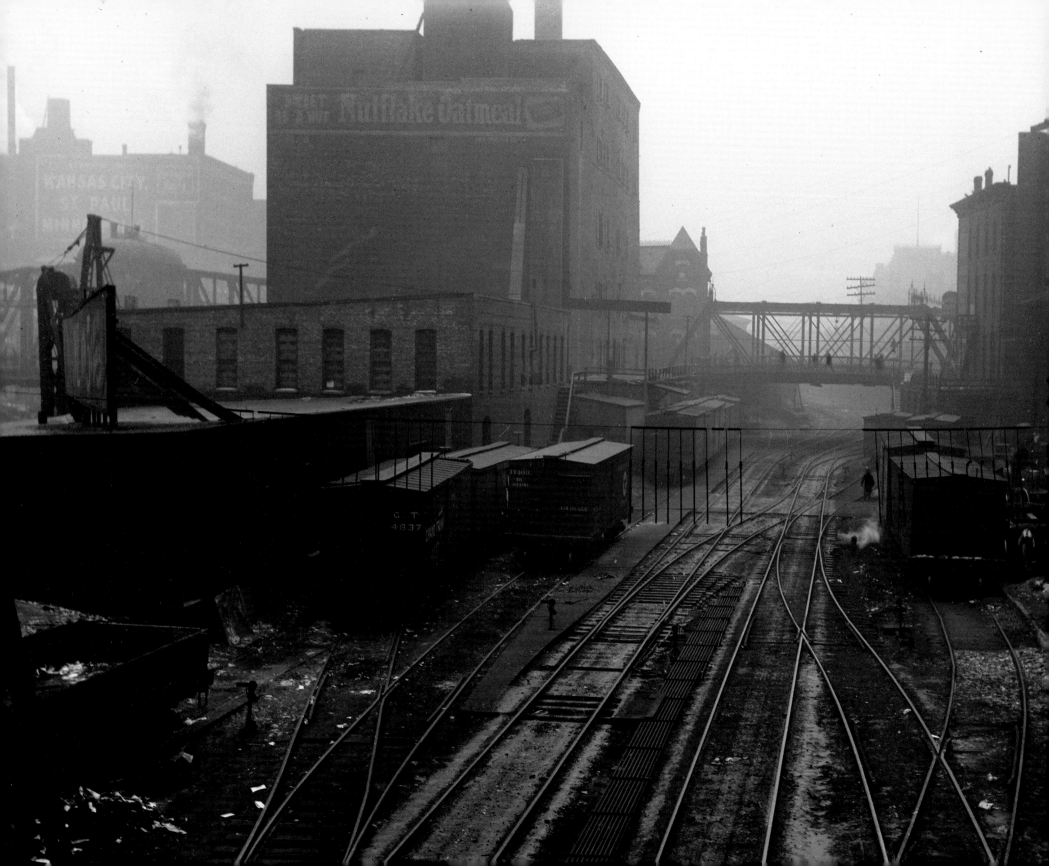

▲ Mile 325.5: Looking east at a signal house near the Madison Street railroad bridge on the west side of the Chicago River.

◄ Mile 325.6: The west bank of the Chicago River in 1903 from the Washington Boulevard Bridge. The Chicago Daily News transformed the river when it bought air rights above this property to build its headquarters in 1929. Other buildings soon followed. The heavy rope hanging above the tracks, known as telltales, served a warning that a train was approaching a low bridge or tunnel.

 2137-6-13-1902

▲ Mile 325.6: The Star and Crescent Milling Company, on the west side of the Chicago River between Madison and Randolph Streets, was awarded $316,000 in a 1903 condemnation suit that was part of the river widening project. The company built a flour mill on the Calumet River slip near 104th Street, which eventually became part of a General Mills complex.

▶ Mile 325.6: The Randolph Street Bridge being erected in 1903. The Sanitary District favored the rolling lift bridge because it kept the river open from obstructions. The Lake Street Elevated Railroad is in the background. It once served Market Street, but the stub line was torn down when Wacker Drive was built.

2699-3-22-1904

◄ Mile 326.3: Sanitary Trustees voted in 1900 to remove all seventeen center-pier swing bridges in the Chicago River to improve its flow. After the vote, one trustee exhaled: "I feel as if we had won a victory like Dewey's at Manila." The new bridges, all built by the Sanitary District, marked a new era in the city. The old Dearborn Street Bridge, shown after it was struck and damaged by two steamers, was rebuilt in 1907.

▶ Mile 326.4: Eight months after the old State Street Bridge was closed and torn down, onlookers on the river's south bank check the slow pace of construction. Work finally began in October 1902, and the bridge opened to traffic the following March.

2159-7-29-190

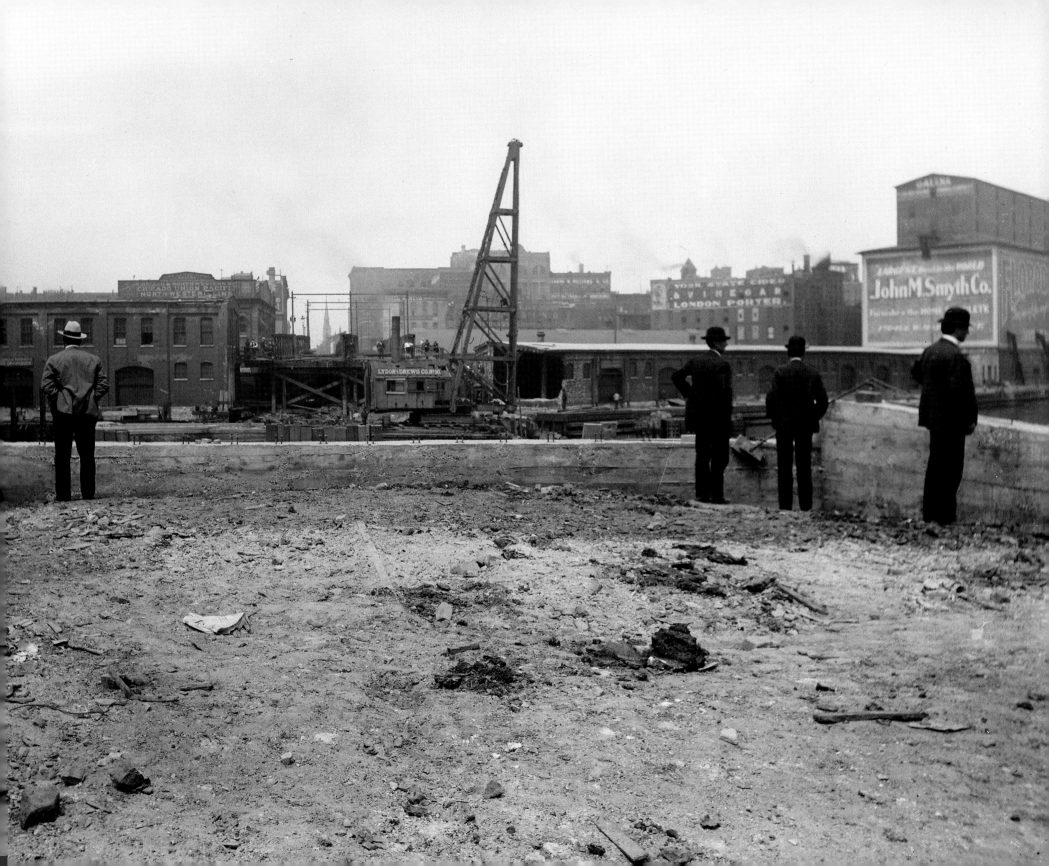

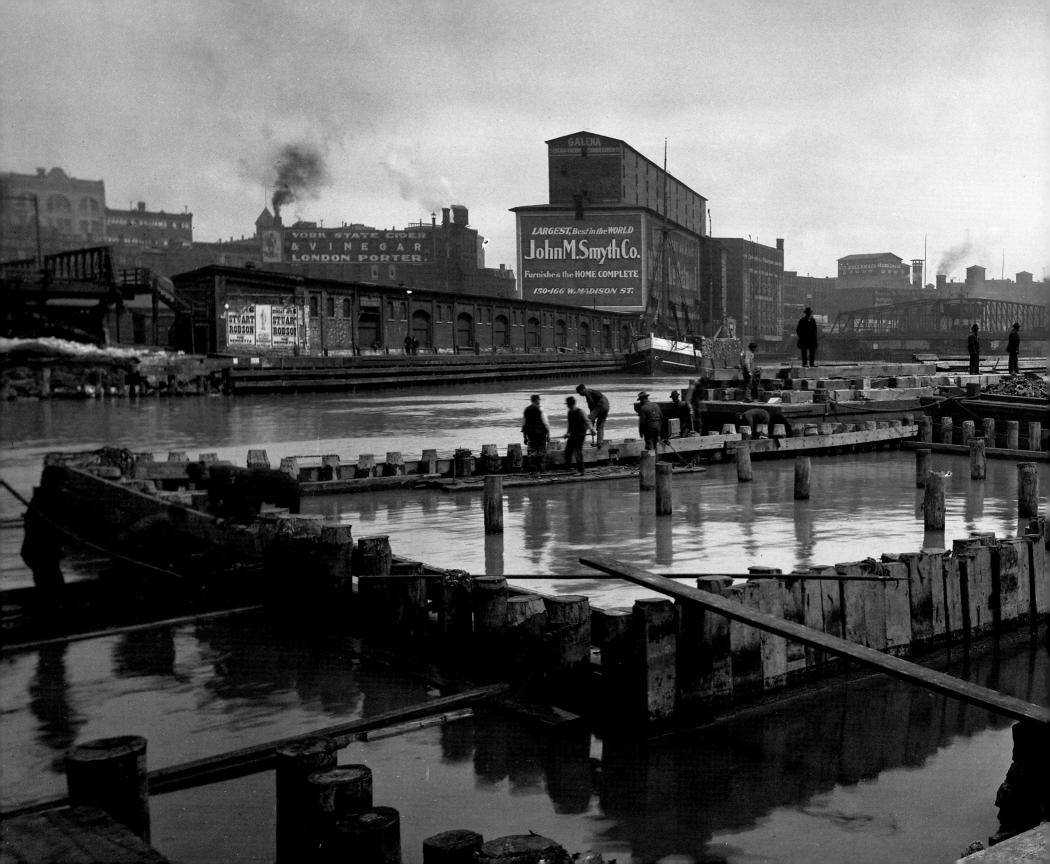

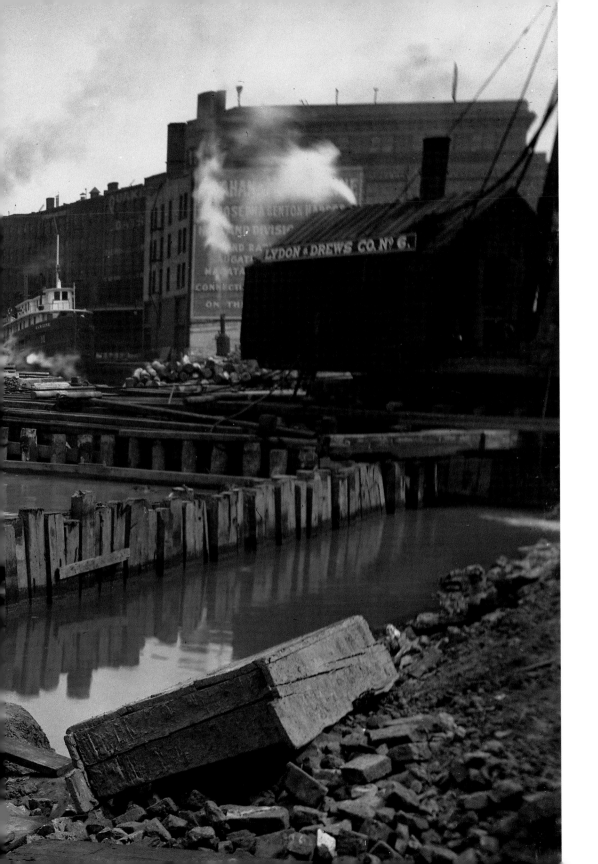

▲ Mile 326.4: A 1902 advertisement for two new productions at the Grand Opera House by Minnie Maddern Fiske, a leading American actress and playwright of the age.

◄ Mile 326.4: A cofferdam was built in 1902 so that workers could pour concrete for the subsection of the State Street Bridge. But the wooden barrier often leaked, which added to construction delays. This view is from the south bank looking northeast. The Rush Street Bridge is in the background.

Mile 326.4: The packed excursion boat THEODORE ROOSEVELT heads east under tow toward Lake Michigan under the State Bridge in 1910. The ROOSEVELT operated between Chicago and Michigan City in the day and made a moonlight lake run in the evening. The passenger boat business boomed until the EASTLAND rolled over just off the south bank of the Chicago River between Clark and LaSalle Streets in 1915 with 2,752 passengers aboard. More than 800 drowned. The Sanitary District was named as a defendant in early lawsuits, charged with dangerously increasing the flow of the river, but a federal judge determined the current did not cause the accident.

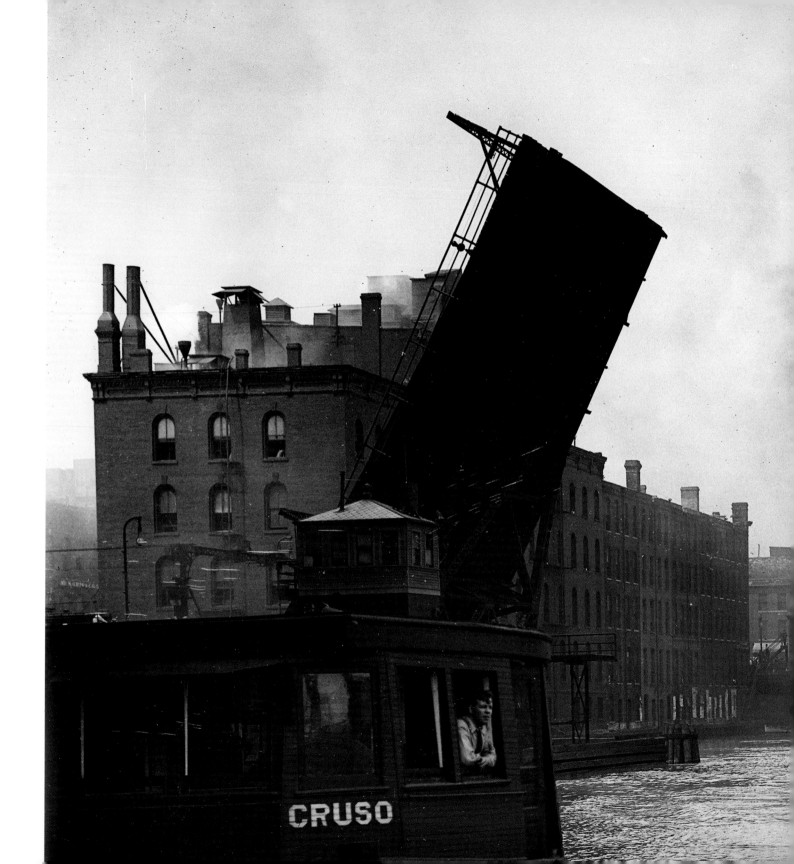

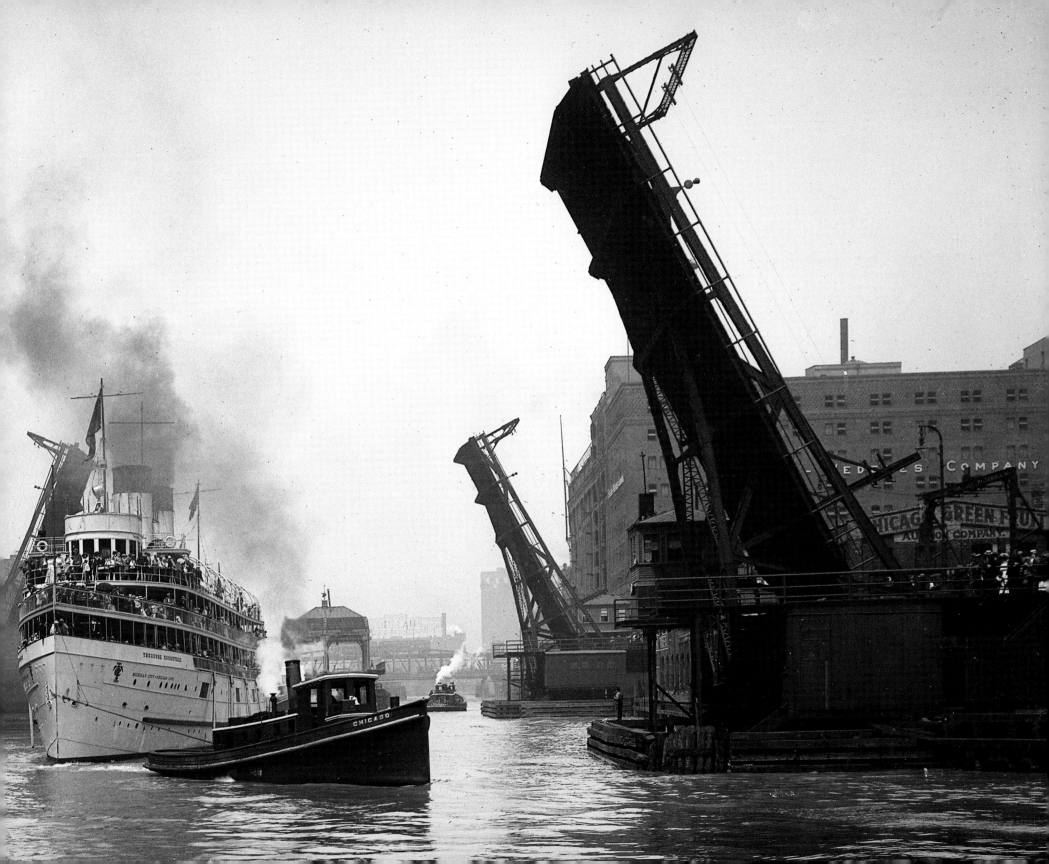

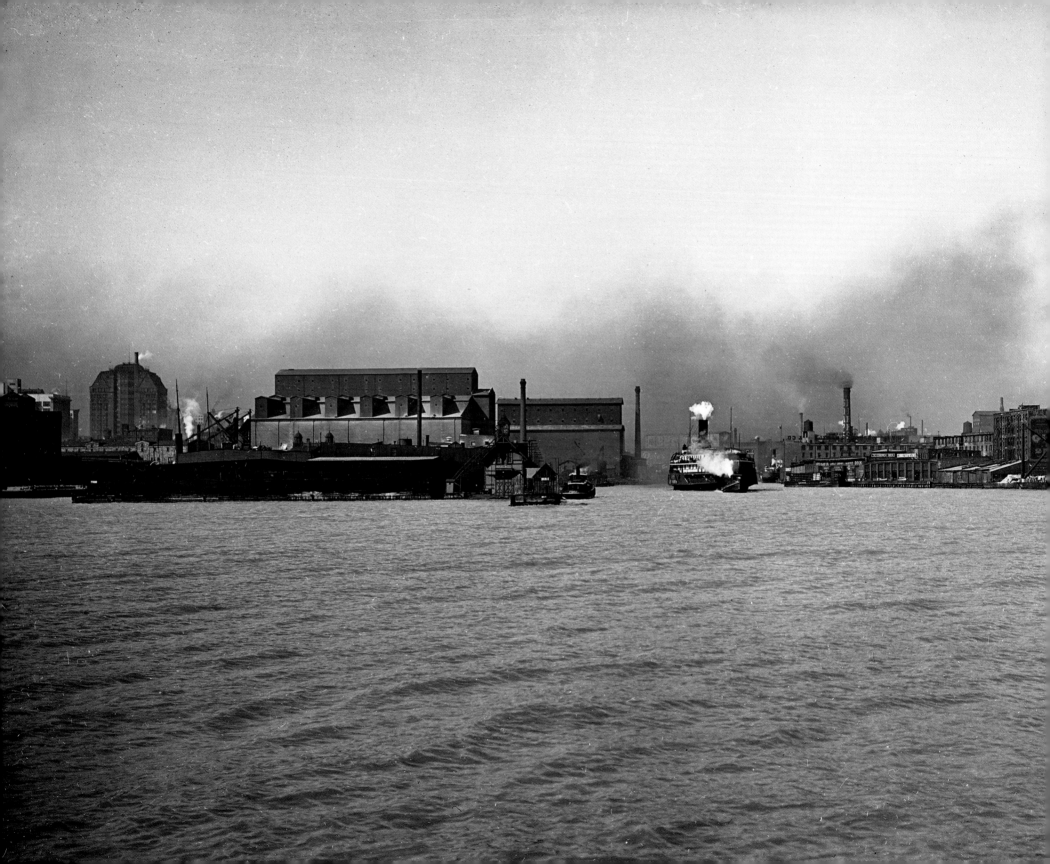

▲ Mile 327: End of the journey at the mouth of the Chicago River around 1900. This image is from a lantern slide, a primitive photographic transparency that was found among the district's glass-plate negatives. It shows makeshift waterfront piers, shacks, and the United States Life Saving Station. Photographers also headed north along the North Branch toward the head of the river.

◄ Mile 327: The vista of the Chicago River from Lake Michigan in 1910. Locks that control how much lake water enters the river were not built until the late 1930s, after the U.S. Supreme Court ordered the Sanitary District to limit the flow of water. Novelist Theodore Dreiser called the Chicago River "the smallest and busiest in the world."

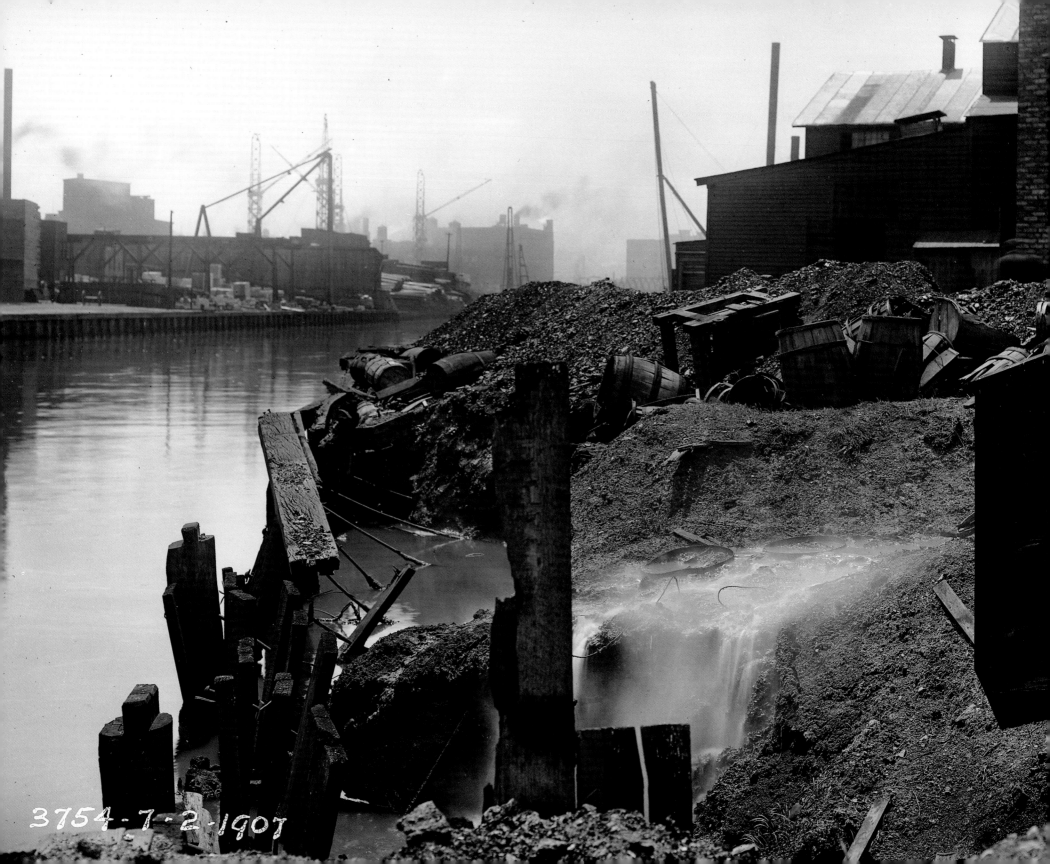

3754-7-2-1907

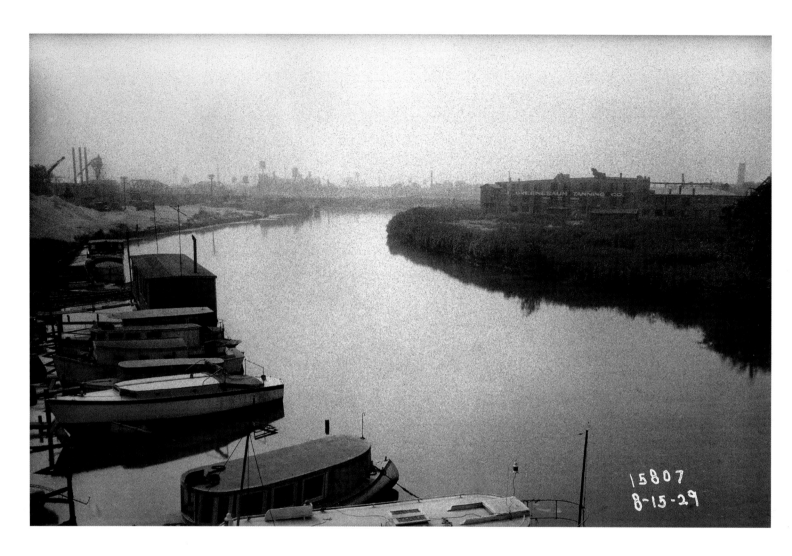

▲ Looking south from Belmont Avenue at houseboats lining the east side of the Chicago River. The J. Greenbaum Tannery is on the opposite bank, and the Western Avenue Bridge is in the distance.

◄ Direct discharge into the Chicago River from the W. N. Eisendrath & Company Tannery. About thirty tanneries, which turned animal hides from the stockyards into leather products, once lined the North Branch. Owners depended on the river for water to clean their facilities and to remove its waste. Along with the stockyards, distilleries, and gas manufacturers, they created what has been called a toxic stew. The North Branch began to smell in the 1870s. Laws were never effective in stopping pollution because the city depended on these businesses.

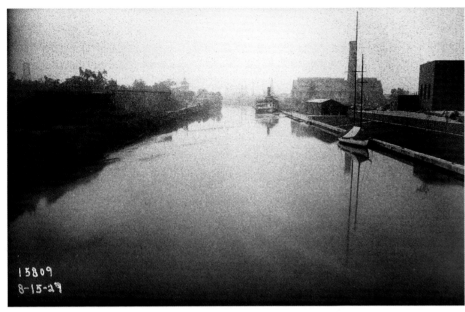

SOUTH FROM THE ADDISON STREET BRIDGE

NORTH FROM THE ADDISON STREET BRIDGE

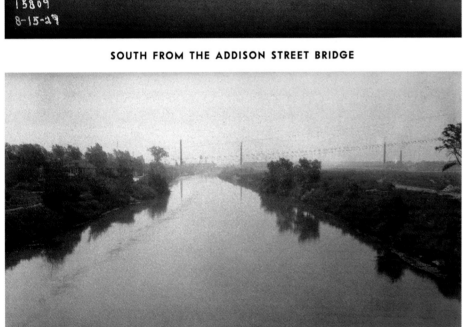

SOUTH FROM MONTROSE AVENUE BRIDGE

NORTH FROM THE MONTROSE AVENUE BRIDGE

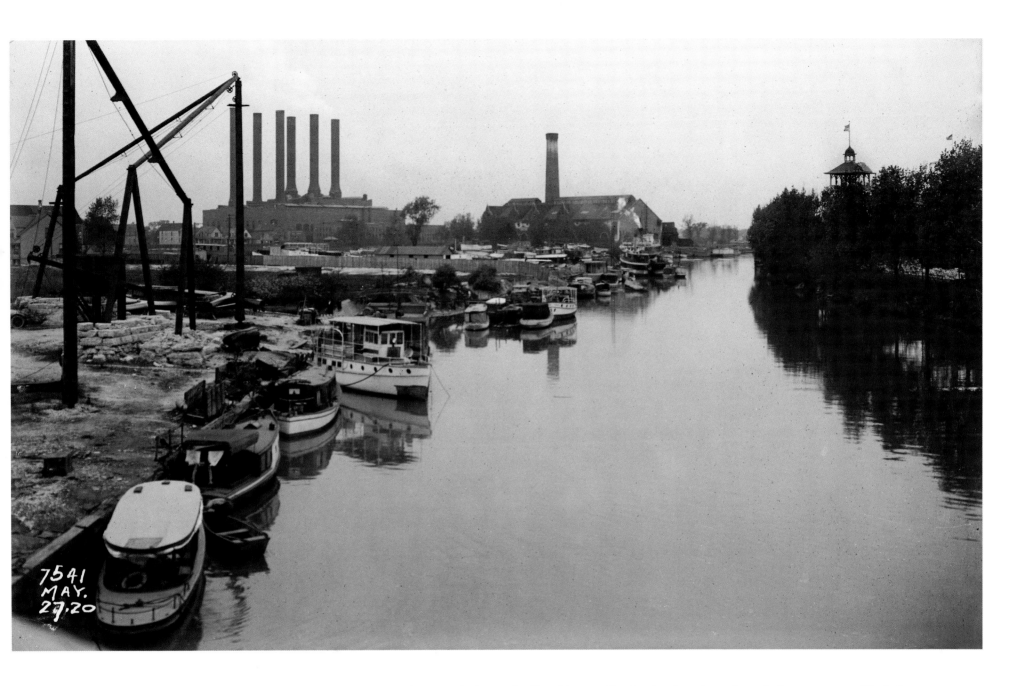

Looking north from the Belmont Avenue Bridge along the North Branch. The Henry C. Grebe boatyard and Commonwealth Edison Northwest Station electric-generating plant are on the west bank. The Grebe Company, opened in 1926, designed and built yachts and constructed minesweepers for the Navy during World War II. The ships were launched sideways with a huge splash. Riverview Park was on the east bank. Operators used the river in the early part of the century for the amusement park's Marine Causeway. The Battle of the Monitor and Merrimac, advertised as one of the "greatest spectacles ever placed before the world," made its debut in 1908 on the river.

4111-7-12-1909

The Lawrence Avenue Bridge along the North Branch. Chicago built a tunnel beneath Lawrence Avenue that connected Lake Michigan with the Chicago River at Lawrence and Kedzie Avenues. The tunnel brought fresh lake water into the river and served as an intercepting sewer on the North Side. It opened in 1908—with a blast of dynamite.

NORTH FROM WILSON AVENUE

EAST BETWEEN TROY STREET AND ALBANY AVENUE

WEST BETWEEN TROY STREET AND ALBANY AVENUE

SOUTHEAST TO KEDZIE AVENUE

▲ Children skinny-dip in a temporary pond along the North Shore Channel between Oakton and Main Streets in Skokie. The Sanitary District built the connection to Lake Michigan during the early 1900s to speed the flow of the North Branch of the Chicago River. Spoil from the channel went to build Gillson Park in Wilmette.

▶ The northern terminus of McCormick Boulevard just west of the North Shore Channel in 1925. This photo was taken from the Chicago and Northwestern tracks looking southwest across Green Bay Road toward Grant Street in Evanston. The Sanitary District built the road to encourage the sale of district-owned land along the channel.

7827
SEP.
12-20
PLATE I-

The Wilmette breakwater and harbor from the south bank of the North Shore Channel in Evanston. The eight-mile channel starts at the Wilmette lakefront, slightly northeast of the Baha'i Temple. The dredge boat in the background is working to deepen the harbor. This is one of few multiplate panoramas of the Chicago area in the Sanitary District's collection.

▲ Workers test the Skokie River at Willow Road near the present-day Skokie Lagoons and Chicago Botanic Garden. This was the farthest north the Sanitary District photographed.

◄ A team of horses helps clear fallen trees and other debris in 1926 from the North Branch near Lake Street in Glenview, just west of what is today the Edens Expressway. Even the trickle of water from the far North Branch added to the flow toward the Mississippi. Three small steams near Deerfield, Glencoe, and Winnetka once served as the headwaters of the Chicago River's North Branch. The pictures are among the last taken on glass-plate negatives, as the process was phased out in favor of more modern plastic-based film negatives. The glass plates remain; film from that period has disintegrated. ✈

EPILOGUE

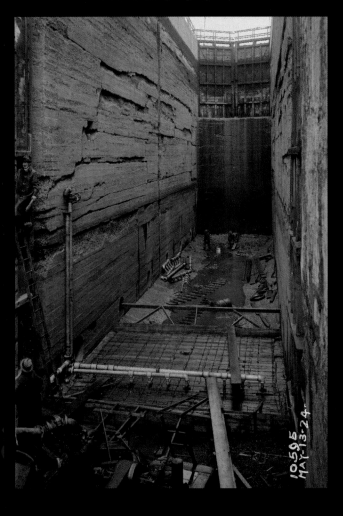

10595 MAY-13-24

▲ THE CONCRETE WALLS OF THE LOCK AT LOCKPORT ARE REPAIRED. THE LOCK IS NEAR THE END OF THE CHICAGO SANITARY AND SHIP CANAL, WHICH WAS EXTENDED IN 1907 FOUR MILES SOUTH FROM THE CONTROLLING WORKS.

▶ EVEN THOUGH THE REVERSAL OF THE RIVER WAS COMPLETED IN 1900, PROJECTS CONTINUE.

CHICAGO'S SANITARY AND SHIP CANAL was an engineering feat, but an environmental flop for those who lived along the Des Plaines and Illinois Rivers.

The canal saved Lake Michigan, and made it possible for Chicago to grow and prosper, enabling it to become the city it is today.

The canal won early raves. The city's death rate was the lowest of any large city in the world in 1904, according to the Chicago Department of Health. Typhoid fever and other waterborne diseases decreased precipitously during the first decades of the twentieth century.

But the canal also had its critics. Less than two years after it opened, following a spike in typhoid fever, *The Journal of the American Medical Association* maligned the project. "It comes very much like a shock when one is told by competent authority, backed by undeniable testimony, that from a sanitary standpoint the canal is a failure, a blunder; that after an expenditure of forty to fifty million dollars the city of Chicago is without wholesome water; that typhoid fever, the infallible curse of sewage polluted drinking water, still is and has been rampant in the city, which continues to be a center for dissemination of typhoid bacilli to all parts of the surrounding country," the journal editorialized. "It is humiliating and in every way unpleasant to know that the most progressive of cities should fail so utterly in its grandiose effort to render itself healthful."

The problem: Sewage from 200,000 Chicagoans (mostly on the South Side) was still ending up in Lake Michigan.

During the next century or so, the district worked diligently to correct that danger. Suburbs that dumped directly into Lake Michigan joined the district, sewer outlets that led into the lake were closed, and an extensive network of

intercepting sewers was built to gather sewage from the entire metropolitan area. Dilution *was* the solution to pollution—for awhile. Waste from Chicago's growing population (1.1 million in 1890, 1.7 million in 1900, 2.2 million in 1910, 2.7 million in 1920) simply became too much for the Illinois River to purify on its own, and new solutions were searched out.

In 1919, Sanitary District trustees voted to construct wastewater treatment plants to remove contaminants and clean the sewage before sending it downstream. In true Chicago style, the Stickney Water Reclamation Plant was built to be the largest in the world. And in 1972, the district approved the Tunnel and Reservoir Plan, a colossal system that collects and stores storm water and sewage following severe storms before sending it for treatment. Still under construction, the Deep Tunnel project is one of the most expensive public works projects in the nation's history. But as built today, TARP—like most municipal sewer systems across the nation—is no match for frequent and intense storms.

The Illinois River is cleaner now than it was before the treatment plants started operating. The U.S. Supreme Court has greatly limited the flow of lake water through the Sanitary and Ship Canal. But it will take generations to reverse what was done. The Illinois—like the Nile, Amazon, and Mekong Rivers—used to depend on the rise and fall of floodwaters during the year to recharge the soil along its banks. Most of that soil is now inundated all year round. The river, along with new locks and dams and farm runoff, has changed the ecosystem forever.

As ducks and fish fled the river and took with them hunters and fishermen, towns that once depended on the Illinois—Pekin, Havana, Beardstown, Meredosia, Pearl, and many

PLAINES MOSQUITO ABATEMENT, 1924

WESTERN AVENUE BRIDGE REPAIR, 1923

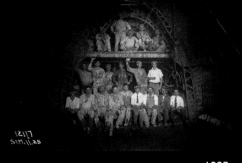

NORTH SIDE SEWER WORKERS, 1925

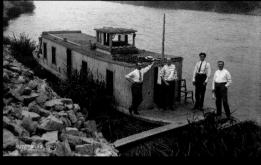

SURVEY PARTY IN JOLIET, 1909

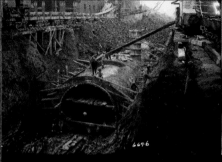

113TH AND MICHIGAN, 1918

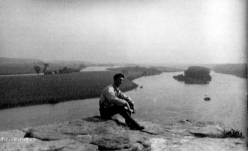

STARVED ROCK PARK, 1907

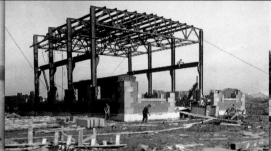

CALUMET POWER PLANT, 1925

BRIDGE CONSTRUCTION IN EVANSTON, 1923

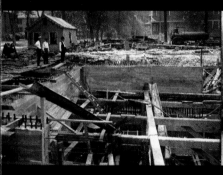

NTRAL STREET IN EVANSTON, 1919

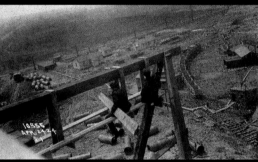

NORTH SIDE SEWAGE PLANT, 1924

NEAR THE CAL-SAG CHANNEL, 1921

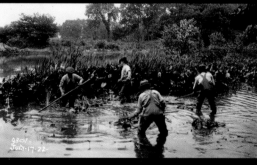

DES PLAINES RIVER CLEANING, 1922

OAD WORK IN MAYWOOD, 1925

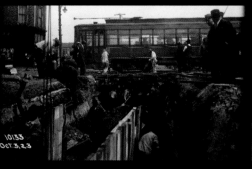

CALUMET SEWER PROJECT, 1923

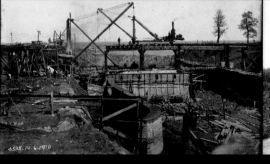

WILMETTE PUMPING STATION, 1910

INVESTIGATING CLAIM IN EVANSTON, 1924

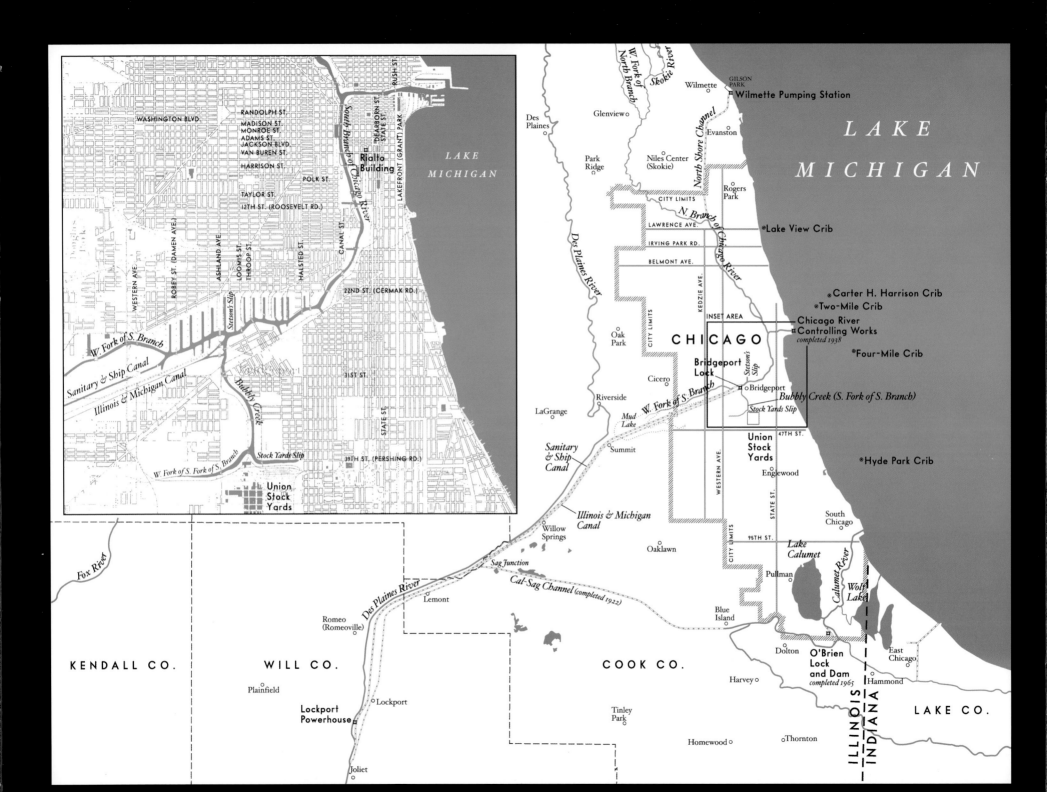

Inset map (upper left):

WASHINGTON BLVD.

RANDOLPH ST.
MADISON ST.
MONROE ST.
ADAMS ST.
JACKSON BLVD.
VAN BUREN ST.

HARRISON ST.

POLK ST.

TAYLOR ST.

12TH ST. (ROOSEVELT RD.)

22ND ST. (CERMAK RD.)

31ST ST.

39TH ST. (PERSHING RD.)

Rialto Building

South Branch of Chicago River

Lakefront (Grant) Park

RUSH ST.
DEARBORN ST.
STATE ST.
CANAL ST.

WESTERN AVE.
ROBEY ST. (DAMEN AVE.)
ASHLAND AVE.
LOOMIS ST.
THROOP ST.
HALSTED ST.
STATE ST.

LAKE MICHIGAN

W. Fork of S. Branch
Sanitary & Ship Canal
Illinois & Michigan Canal
Stetson's Slip
Bubbly Creek
W. Fork of S. Fork of S. Branch
Stock Yards Slip

Union Stock Yards

Main map:

W. Fork of North Branch
Skokie River
W. Fork of North Branch

Wilmette
GILSON PARK
⊡ Wilmette Pumping Station

Des Plaines

Glenview

Evanston

North Shore Channel

LAKE MICHIGAN

Park Ridge

Niles Center (Skokie)

Rogers Park

CITY LIMITS

N. Branch of Chicago River

LAWRENCE AVE.
⊚ Lake View Crib

IRVING PARK RD.

BELMONT AVE.

Des Plaines River

KEDZIE AVE.

⊚ Carter H. Harrison Crib

⊚ Two-Mile Crib

Oak Park

CITY LIMITS

INSET AREA

CHICAGO

Chicago River
Controlling Works
completed 1938

⊚ Four-Mile Crib

Bridgeport Lock

Stetson's Slip

Cicero

○ Bridgeport

Bubbly Creek (S. Fork of S. Branch)

Riverside

W. Fork of S. Branch

Stock Yards Slip

LaGrange

Mud Lake

Union Stock Yards

47TH ST.

⊚ Hyde Park Crib

Sanitary & Ship Canal

Summit

Englewood

WESTERN AVE.

STATE ST.

South Chicago

Illinois & Michigan Canal

Willow Springs

Oaklawn

95TH ST.

CITY LIMITS

Lake Calumet

Calumet River

Sag Junction

Cal-Sag Channel (completed 1922)

Des Plaines River

Lemont

Pullman

Wolf Lake

Fox River

Romeo (Romeoville)

Blue Island

KENDALL CO.

WILL CO.

COOK CO.

Dolton

O'Brien Lock and Dam
completed 1965

East Chicago

Plainfield

Lockport

Harvey

Hammond

ILLINOIS
INDIANA

LAKE CO.

Tinley Park

Lockport Powerhouse

Homewood

Thornton

Joliet

others—were set on a new course. No longer was there timber to cut, animals to trap, or ice to manufacture in the winter. It is no wonder that biologists and geologists who surveyed the river always noted the high level of resentment that locals carried for Chicago and its drainage ditch. They felt they had been sold a bill of goods.

Fifteen years after the canal was opened, the Chicago Real Estate Board issued a report prepared by outside sanitary engineers who had spent a year studying the Illinois River. "The water is not fit to drink, not to wash in, nor to water stock in, nor for the many other domestic and industrial uses of a normal river," they wrote. "Fish die in it; the thought of swimming in it is repugnant to the senses; boating, far from being a pleasant and healthful diversion, can be enjoyed only by the hardy."

In 1924, downstate resident Franklin L. Velde testified before the Illinois Valley Flood Control Commission that the construction of the canal by the district was "the greatest crime ever perpetrated on any part of this country, permitting them to ruin a people as they have done to the landowners throughout the Illinois River Valley." In 1940, William B. Philip concluded his doctoral dissertation for the University of Chicago by writing: "The magnitude of the pollution of the Illinois River was unprecedented in the nation."

Missouri lost its case against Illinois and the Sanitary District in the U.S. Supreme Court. More than fifty scientists were hired to determine whether Chicago's sewage was polluting St. Louis's drinking water. The battle of bacteriologists ended in a stalemate, but the district prevailed because Missouri's case had a fatal flaw: St. Louis was dumping *its* sewage down the Mississippi.

Nobody knew for sure whether the canal envisioned by Ossian Guthrie would work as planned. It did. Without pumps or machinery, the Chicago River began to flow southwest toward the Des Plaines and Illinois Rivers instead of east toward Lake Michigan. And it has continued to do just that for more than a century.

In 1955, the canal and wastewater system was named one of the seven wonders of American engineering by the American Society of Civil Engineers, joining the Empire State Building, the Hoover Dam, the Colorado River Aqueduct, the Grand Coulee Dam and Columbia Basin Project, the Panama Canal, and the San Francisco–Oakland Bay Bridge. A plaque outside the entrance of the Metropolitan Water Reclamation District of Greater Chicago headquarters, at 100 East Erie Street, commemorates the honor. The canal has been called the eighth wonder of the world in many accounts.

Ossian Guthrie? In 1907, after outliving four of his wives, he announced that he would wed again. "I am by no means too old to get married," he told a reporter in a curious story that got picked up by the *New York Times*. "The whole marriage proposition revolves itself into a similar position with the lady and gentleman strangers who find themselves alone on a railroad coach, both lonely and wondering if they should speak—and, if the lady is willing it's all right. I believe in just letting things happen." In his obituary the following year, he was called the "father of Chicago's drainage system."

Sanitary District engineer Lyman Cooley never got to see his dream fulfilled. He died in 1917. The 327-mile Illinois Waterway, which connects Lake Michigan with the Mississippi River through seven locks and dams, was not completed until the 1930s.

The giant spoil banks that once lined both sides of the Main Channel, known as the Sierra Mountains, are gone. It has taken more than a century, but the material removed to create the canal has been bought up by contractors.

In 1995, a species of fish called the Asian carp showed up in the Illinois River after escaping from fish floods in Arkansas. The carp—which devour half their body weight every day in algae and plankton—are unlike any fish the river has ever seen. One type, the silver carp, leaps out of the water at the sound of boat motors, often flopping into the back of boats, even striking boaters. They have captured our attention.

The electronic barrier installed in the Sanitary and Ship Canal near Romeoville in 2002 has stopped the Asian carp, at least temporarily, but worries persist that the fish will advance into Lake Michigan. There is talk of building a permanent barrier in the canal to hold back the carp and the zebra mussels that enter the Chicago River from Lake Michigan, but the obstruction would also block navigation and the flow of water that sustains the metropolitan area. And there is talk of re-reversing the Chicago River so that it would send treated and disinfected sewage back into Lake Michigan. Perhaps, the thought goes, the Sanitary District went too far in engineering nature, and we must separate the watersheds once again.

There is little left that can be called natural in this waterway today. Re-reversing it won't bring back the forests, floodplains, marshes, prairies, wildcats, bustards, and other wildlife that Jolliet and Marquette saw hundreds of years ago. But in these lost panoramas, a part of historic Illinois is documented forever. Depending on your point of view, these images may inspire you or haunt you. Or both. ᴗ

SOURCES

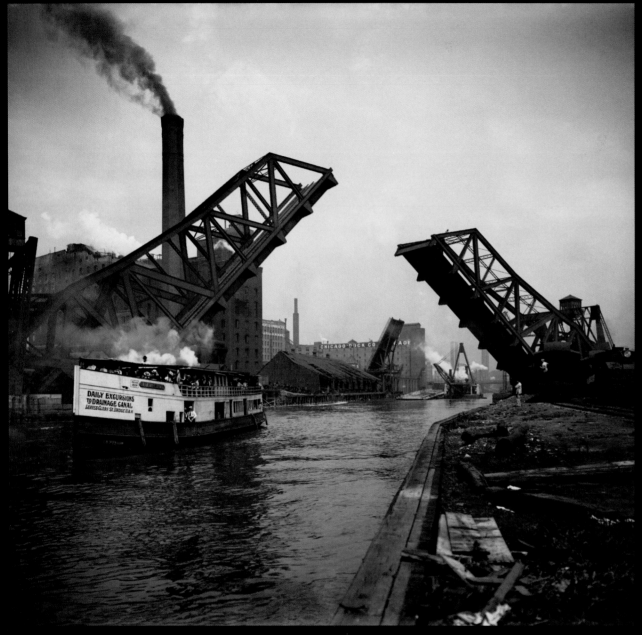

AN EXCURSION BOAT PASSES UNDER THE RAILWAY BRIDGE AT 12TH STREET AS IT HEADS DOWN THE
SOUTH BRANCH ON ITS WAY TO THE DRAINAGE CANAL. (LIBRARY OF CONGRESS)

WE STARTED OUR RESEARCH at the library of the Metropolitan Water Reclamation District of Greater Chicago. Here you can find books on aerobiology, sludge treatment, water supply economics, fresh water algae, lubrication and lubricants, soil fungi, reverse osmosis, steam turbines, and the principles of desalination. And it's here you can read the City of Chicago Building Code; the Proceedings of the Rapid Excavation and Tunneling Archive; *The Making, Shaping and Treatment of Steel; A History of the St. Lawrence Deep Waterway (A Canadian Perspective),* and *Garbage As You Like It.*

Most of our research revolved around the photographs taken by the district between 1894 and 1928. We studied thumbnail images of each photograph scanned during the late 1990s, and matched them up with field books. That gave us a sense of where and when each photograph was taken. We then made a list of what we felt were the most telling photographs, and headed to the Illinois State Archives to scan about nine-hundred glass-plate negatives. Carting the heavy negatives was arduous, but we managed to get through the collection with breaking only one plate. (It's okay: We first made the scan.)

That's when our work really began, because we had to make sense of the collection. We started with the construction of the Drainage Canal. No full-length narrative has ever been written on the canal, so we read contemporary accounts. By far the most helpful was *The Chicago Main Drainage Canal: A Description of the Machinery Used and Methods of Work Adopted in Excavating the 28-Mile Drainage Canal from Chicago to Lockport, Ill.,* by Charles Shattuck Hill, 1896, The Engineering News, New York. As much as we valued the remarkably detailed descriptions of the machines used to

carve the canal, we most relished the full-page ads for steam shovels, air compressors, rock drills, and self-righting hoisting buckets. Don't trust us; download your copy online.

Also helpful was the unpublished 1999 manuscript "So They Reversed the River: A History of the Construction of the Main Channel and Improvements to the Chicago and Des Plaines River from 1892 to 1900 for the Reversal of the Chicago River," by Richard Lanyon, who was district's assistant director of research and development at the time.

We depended on dozens of books and publications produced and published by the Sanitary District. Most helpful was *Drainage Channel and Waterway,* by G. P. Brown, 1894, also available online, which gives the most complete background to the formation of the district. Also useful were: *The Sanitary District of Chicago, and the Chicago Drainage Canal. A Review of Twenty Years of Engineering Work,* by Isham Randolph, 1909; *The Diversion of the Waters of the Great Lakes by Way of the Sanitary and Ship Canal of Chicago,* by Lyman E. Cooley, 1913, and *Engineering Facts Concerning the Sanitary District of Chicago,* 1923. The district keeps a year-by-year copy of the Proceedings of the Board of Trustees of the Sanitary District of Chicago, which assisted us in finding elusive information about the photography project.

Other first-hand accounts were the unpublished 1918 manuscript "Lecture: Origin and Development of The Sanitary District of Chicago Illustrated with 180 Lantern Slides," by E. H. Heilbron, and *Gleanings from A Harvest of Memories,* by Isham Randolph, 1937, privately printed by E. W. Stephens Co., Columbia, Missouri.

Our principal contemporary resource was the digitalized *Chicago Tribune.* The newspaper was one of eight city dailies at the time, and we looked at each one on microfilm until we became dizzy. We kept turning back to the *Tribune* because of its comprehensive, first-rate coverage of the canal story. William Boldenweck, president of the Sanitary District, hired a clipping service to compile a nineteen-volume scrapbook of newspaper clippings about the district from 1897 to 1900. That scrapbook is at the Chicago History Museum, and we were probably the first to leaf through the clips, kept together with straight pins. We also perused a scrapbook of clips relating to Ellis Chesbrough, the engineer who built the two-mile water crib. Long live reporters, who write history every day, and museums and libraries that keep that history.

The Illinois Waterway runs through twenty-two counties. The Newberry Library, where co-author Richard Cahan served as an Arthur and Lila Weinberg Fellow, possesses histories of most of them. They offer insight into the land the rivers crossed. Our favorite was *History of LaSalle County Illinois,* by Elmer Baldwin, 1877, Rand, McNally, Chicago. It, too, is online. Even more local was *Lemont and Its People, 1673-1910,* by Sonia Aamot Kallick, 1998, Chicago Spectrum Press, Louisville, Kentucky, which helped us understand the particular role that Lemont played in the canal.

The Newberry also holds two manuscripts by Ossian Guthrie: "The Great Lakes and Their Relations to the Lakes and Gulf Water-Way," written in 1888, and his 1896 "Relics Turned up in the Drainage Canal." (Don't you love these titles?)

We relied on three outstanding books that helped us comprehend the big picture. They are the sweeping *City of the Century: The Epic of Chicago and the Making of America,* by Donald L. Miller, 1996, Simon & Schuster, New York; the insightful *Nature's Metropolis,* by William Cronon, 1991, W. W. Norton, New York, and the inspiring *Shock Cities: The Environmental Transformation and Reform of Manchester and Chicago,* by Harold L. Platt, 2005, University of Chicago Press, Chicago. To understand the Chicago River, we read the second edition of *The Chicago River: An Illustrated History and Guide to the River and its Waterway,* by David M. Solzman, 2006, University of Chicago Press, Chicago, and *The Chicago River: A Natural and Unnatural History,* by Libby Hill, 2000, Lake Claremont Press, Chicago. Hill's book is the most carefully researched book on the river. In it, she debunks the decades-old myth that 90,000 Chicagoans died of waterborne disease following the August 2, 1885, rainstorm. We scoured city health department records to determine the health ramifications of the storm. She's right. Nobody died, but the storm did lead to the district's formation.

To understand the science behind the Illinois River, we depended on publications by the Illinois State Water Survey, Illinois Natural History Survey, and Illinois State Geological Survey. Most of these are online through the Prairie Research Institute Library website. We were also influenced by the monumental *A Natural History of the Chicago Region,* by Joel Greenberg, 2002, University of Chicago Press, Chicago, and by several talks with him comparing notes.

Every photograph in this book helps tell a story, and there is a story behind each one. To understand them, we primarily depended on the photographers' field books. Although we questioned every entry, we found that the photographers were exceptionally accurate

in their notes. To understand the nineteenth century surroundings in each photograph, we used the detailed 1902-1905 maps of the Illinois and Des Plaines Rivers (Pages 38 and 39) by J.W. Woermann, assistant engineer of the U.S. Army Corps of Engineers. To understand what happened during the last century, we drove the entire route, biked the Chicago portions, and talked to local residents. We also depended on Google Maps to give us an aerial view of the river today. It's been quite a trip.

Charlie Goodwin took us across the Illinois and Mississippi Rivers (Page 42) on a ferry to show us the islands; Melvin "Gene" Heffington, of Mel's Illinois River Dock, told us the history of Hardin (Page 45), and the Illinois State Museum's website Harvesting the River explained mussel fishing (Page 46). Linda Akin, Lee Jankowski, and June Johnson helped us track down the story behind the Varner Bridge (Page 49), and Edward Heilbron, alive and well in Texas, reminisced about his father (Page 50). Browning farmers Charles Briney, Leon Stambaugh, and Gene Burton explained how farming has changed over the years (Page 54), and got a good chuckle at the lonely corn stalks.

To understand the lawsuits filed against the district, we depended on *The Sanitary District of Chicago: History of Its Growth and Development,* by C. Arch Williams, published by the district in 1919 and available online, and a two-volume set of records called the Illinois Valley Suits & Claims, compiled by E. H. Heilbron. The best book on the subject is *Wetlands Drainage, River Modification, and Sectoral Conflict in the Lower Illinois Valley,* by John Thompson, 2002, Southern Illinois University Press, Carbondale and Edwardsville, which reads better than the title indicates.

Research on Bailey Falls (Page 68) was directed by Evelyn Moyle, who gives local historians a good name. She recalled wonderful picnics long ago at the falls, and sent us emails brimming with information, maps and photographs. Ken Ficek and Steve Stout filled in the details.

To better understand the river itself, we depended on "The Plankton of the Illinois River, 1894-1899," by C. A. Kofoid, Bulletin of the Illinois State Laboratory of Natural History, 1908, Illinois Printing Company, Danville, Illinois; "Some Recent Changes in the Illinois River Biology," by Stephen A. Forbes and Robert Earle Richardson, 1919, Illinois Natural History Survey, Urbana, Illinois; "The Mussel Resources of the Illinois River," by Ernest Danglade, 1914, U.S. Bureau of Fisheries, Washington, D.C.; "Man's Effect on the Fish and Wildlife of the Illinois River," by Harlow B. Mills, William C. Starrett, and Frank C. Bellrose, 1966, Illinois Natural History Survey, Urbana, Illinois; "Waterfowl Populations and the Changing Environment of the Illinois River Valley," by Frank C. Bellrose, Fred L. Paveglio Jr., and Donald W. Steffeck, 1979, Illinois Natural History Survey, Urbana, Illinois; and "Bank Erosion of the Illinois River," by Nani G. Bhowmik and Richard J. Schicht, 1980, Illinois State Water Survey, Urbana, Illinois. The most up-to-date account of the river is the U.S. Army Corps of Engineers' 2007 Illinois River Basin Restoration Comprehensive Plan. Marshall Plumley, one of its authors, updated the report.

After reading each of these publications, which are all available online, one has to wonder why they are still so obscure.

To better understand the photos of the Illinois and Michigan Canal (Page 83), we read

The Illinois and Michigan Canal: A Contemporary Perspective in Essays and Photographs, by Jim Redd, 1993, Southern Illinois University Press, Carbondale and Edwardsville, and *Prairie Passage: The Illinois and Michigan Canal Corridor,* photographs by Edward Ranney, 1998, University of Illinois Press, Urbana.

Richard Lanyon and the district's Jerome McGovern helped explain every photograph taken in Chicago. We had many spirited email exchanges about exact locations. Gerald Adelmann, president and CEO of Openlands, gave us background about Romeo (Page 90), and toured us through his beloved Lockport. Environmental engineer Naren Prasad and Rosauro Delrosario coached us through the confusing background of coal gas (Page 110), and Lyle Benedict, of the Municipal Reference Library, guided us to information about the Twenty-Second Street Bridge (Page 114). Our frequent co-conspirator Bruce Moffat took us around the 1904 freight sheds (Page 119) on the South Side. He's the one who spotted the hand brake. Tim Samuelson, Chicago's cultural historian and another lifetime co-conspirator, set the scene about the garment-manufacturing district (Page 124). And Sam Guard gave us insight into Chicago River bridges (Pages 130 and 132). He should know; he helped build many of the new ones.

THE VIEWS EXPRESSED in this book in no way reflect those of the book's financial supporters.

Lead sponsor Greeley and Hansen dates back almost a century ago to the Sanitary District, when Samuel A. Greeley accepted a job with the district as an assistant to Langdon Pearse, already a well-respected sanitary engineer. Soon after, the two founded their own

practice—Pearse and Greeley, which has grown into a Chicago-based environmental engineering firm with offices in eighteen cities across the United States.

Sponsor Christopher B. Burke Engineering, founded in 1986, is an engineering and surveying firm based in Rosemont, Illinois, that provides civil, municipal, transportation, water resource, mechanical, structural, construction, traffic, environmental engineering, and environmental resource services.

The Chicago Academy of Sciences has been led by lovers of natural history since its founding in 1857 by Robert Kennicott. The Great Chicago Fire of 1871 destroyed the academy's early collection and library, but they were rebuilt. The academy moved into the Laflin Building in Lincoln Park in 1894. More than a century later, in 1999, the academy moved to the Peggy Notebaert Nature Museum at 2430 North Cannon Drive.

Photographic prints made by the district's first photographer, William Christie, were donated in 1901 to the academy board, which accepted the "very valuable and instructive" gift with unanimous thanks. "We shall properly install and place on exhibition both the models and photographs as soon as possible," wrote secretary William K. Higley. "It will give us pleasure to exhibit them to visiting engineers and those in other avocations that you may refer to us."

Now, 110 years later, the academy's Peggy Notebaert Nature Museum has rediscovered the Sanitary District photographs. In 2010, the museum exhibited "The Lost Panoramas," the first look at the work, and in 2011 it helped sponsor this book of photographs. Like all art, the photos are timeless. ✍

OSSIAN GUTHRIE, CIRCA 1885

E. H. HEILBRON'S CONFIDENT SIGNATURE

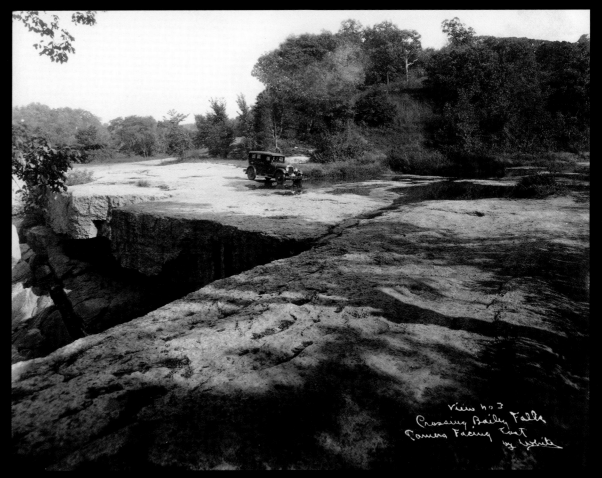

ONE OF MANY OLD PHOTOS FROM EVELYN MOYLE TO HELP BETTER UNDERSTAND BAILEY FALLS

INDEX

In memory of William H. Griffith Jr., an engineer who firmly believed that technology could improve the world. He would have loved every detail.